MODERN MASTERS

JACKSON POLLOCK

ELIZABETH FRANK

Abbeville Press · Publishers
New York · London · Paris

Jackson Pollock is volume three in the Modern Masters series.

ACKNOWLEDGMENTS: I wish to acknowledge my indebtedness to previously published writings about Jackson Pollock, in particular those by Clement Greenberg and William Rubin, although the work of Lawrence Alloway, Michael Fried, Rosalind Krauss, Francis V. O'Connor, Barbara Rose, and Pollock's numerous "Jungian" critics I have found informative and provoking.

Lee Krasner Pollock has generously answered numerous questions about her late husband's life and work, and I am grateful to her for her time and help. William S. Lieberman and Francis V. O'Connor have also provided valued aid. Finally, I owe a special debt to Howard Buchwald, to whom this book is dedicated.

FRONT COVER: Detail of *Convergence: Number 10, 1952*, 1952. See plate 89.
BACK COVER: *Male and Female*, 1942. See plate 29.
ENDPAPERS: Jackson Pollock. Photographs by Rudolph Burckhardt.
FRONTISPIECE: *Phosphorescence*, 1947. Oil and aluminum paint on canvas, 44 x 26 in. Addison Gallery of American Art, Phillips Academy, Andover, Massachusetts.

Series design by Howard Morris
Editor: Nancy Grubb
Designer: Gerald Pryor
Picture Editor: Christopher Sweet
Production Manager: Dana Cole
Chronology, Exhibitions, Public Collections, and Selected Bibliography compiled by Anna Brooke

Marginal numbers in the text refer to works illustrated in this volume.

Library of Congress Cataloging-in-Publication Data

Frank, Elizabeth, 1945– .
 Jackson Pollock.

 (Modern master series, ISSN 0738-0429; v. 3)
 Bibliography: p.
 Includes index.
 1. Pollock, Jackson, 1912–1956. 2. Painters—
United States—Biography. 1. Title. 11. Series.
ND237.P73F67 1983 759.13 83-3856
ISBN 0-89659-383-5
ISBN 1-55859-254-7 (pbk.)

First edition, fifth printing

Contents

Introduction

This book is intended to serve as a general survey of the life and work of Jackson Pollock, the foremost member of the first generation of "Abstract Expressionists," which came to maturity just after World War II, and the greatest twentieth-century American painter. Undergraduate art and art history students should find the essential questions of Pollock studies touched on here, while the advanced student, working artist, and art lover should find material for both the deepening and refreshment of interest.

Now that Pollock's stature is an accepted fact of American cultural life, it is easy to forget the uncharted and bumpy road his reputation had to follow. Apart from two or three early sympathetic reviews by Robert Coates and Manny Farber, and Clement Greenberg's impassioned annunciations in *The Nation*, *Horizon*, and *Partisan Review*, Pollock's critical reception, most particularly where the popular press was concerned, tended toward a baffled skepticism and a derisive emphasis on the apparent unconventionality of his working methods. Battle lines were drawn between his "highbrow" supporters, who saw in his art America's triumphant catching-up with the great modern tradition, and his "lowbrow" detractors, who could not for the life of them understand what it was in his drips and spatters that could be called *art*. His 1947–50 "poured" paintings were compared, in *Life* magazine, to wallpaper and necktie designs,[1] and as late as 1956, shortly before his death, *Time* flashed its philistine wit in the epithet "Jack the Dripper,"[2] unable to see in Pollock's work or indeed in that of his colleagues (Willem de Kooning, Arshile Gorky, Robert Motherwell, Philip Guston, William Baziotes, Adolph Gottlieb, and Mark Rothko) anything more than an aesthetic confidence game put over on a gullible public.

The first monograph on Pollock, by the late poet Frank O'Hara, appeared in 1959, three years after Pollock's death, and while it leaves much unsaid by way of fact and analysis, it reveals a powerful response to the mythopoeic content of Pollock's art. Bryan Robertson's *Jackson Pollock*, published in 1960, vitiates itself in a flood of mythic portraiture. Pollock-as-existential-cowboy was already a cliché before his death, but Robertson's text does little to

1. *Easter and the Totem*, 1953
Oil on canvas, 82¼ x 58 in.
The Museum of Modern Art, New York
Gift of Lee Krasner in memory of Jackson Pollock

7

2

temper or dispel the romantic and sentimental extremes of this view. B. H. Friedman's biography, *Jackson Pollock: Energy Made Visible*, which came out in 1972, has a similarly sentimental focus, and offers up anecdotes so uncritically that it is difficult to tell where fact leaves off and tall tale begins.

With the appearance in 1965 of Michael Fried's remarks on Pollock's paintings in his catalog *Three American Painters*, a new era of close attention to the visual facts of Pollock's art was initiated—marked, on the one hand, by Fried's acknowledgment of Greenberg's preeminent discussions of Pollock, and, on the other, by the highest standards of art historical research and fidelity to visual experience. The Greenberg-Fried line of thought culminated in William Rubin's superb four-part inquiry into Pollock's relationship to modernism, "Jackson Pollock and the Modern Tradition," in the February, March, April, and May 1967 issues of *Artforum*. These articles, which explore Pollock's synthesis of the logic of Impressionism, Cubism, and Surrealism, should be considered required reading for anyone with a serious interest in his work. An additional and equally fundamental aid to study has been available since 1978 in the form of Francis V. O'Connor's and Eugene V. Thaw's magnificently researched and documented *Jackson Pollock: A Catalogue Raisonné of Paintings, Drawings, and Other Works*.

The 1970s and '80s have witnessed yet another turn in Pollock studies, heralded in 1970 by the appearance of *Jackson Pollock:*

3

Psychoanalytic Drawings, edited by C. L. Wysuph. Since then, a younger generation of art historians has amassed an impressive store of Jungian interpretations of Pollock's works, although their specific readings, which tend to focus on iconography at the expense of structure, are more persuasive as conjectures than as certitudes.

At a time when painting, particularly abstract painting, has found itself under sustained attack from those who hold that modernism is dead, and when careerism, cynicism, and fashion tend to make the self-criticism and struggle of Pollock and his generation seem merely accidents of historical circumstance rather than necessities in an abiding dialogue with their work, it is salutary to begin at the beginning: that is, with looking, in Pollock's case, at his paintings. Their darkness and light, their energy, touch, and splendor of feeling tell us much not only about his temperament, but in their unassailable honesty chart a graph of unfolding development, as rigorous in its logic as it is sublime in expression.

2. (*Landscape with Rider I*), 1933
Oil on tin, dimensions unknown
Location unknown

For an explanation of the use of brackets and parentheses in Pollock's titles, see note on page 18.

3. *Male and Female in Search of a Symbol*, 1943
Oil on canvas, 43 x 67 in.
Private collection

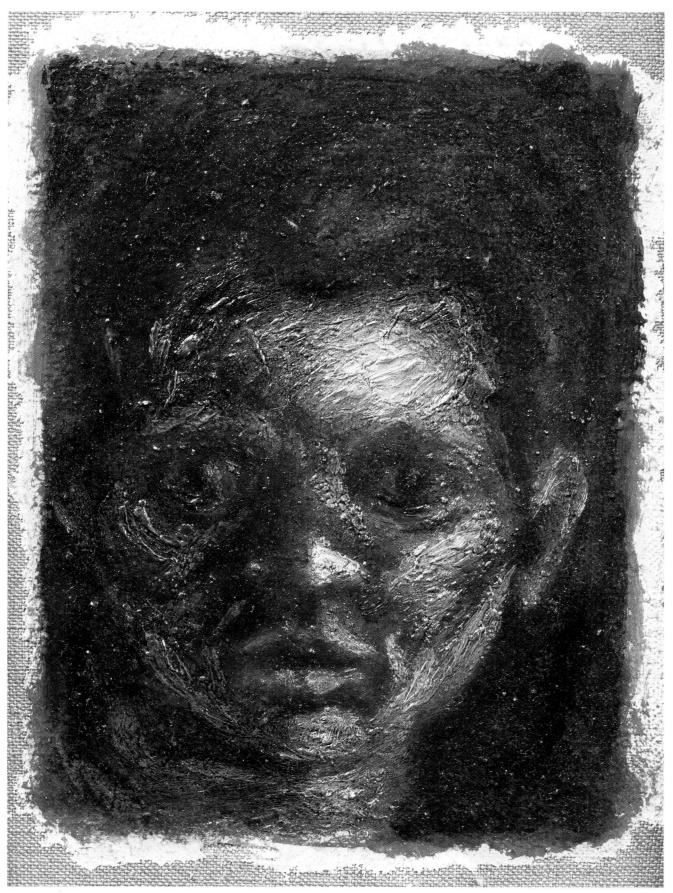

Beginnings, 1912–30

Paul Jackson Pollock was born on January 28, 1912, in Cody, Wyoming. He was the fifth and youngest son of Stella May McClure Pollock and LeRoy Pollock (born McCoy, but adopted in 1897 by a foster family named Pollock), who had both been born in Tingley, Iowa, and were of Scotch-Irish descent.

A good deal of commotion has been made about the fact of Pollock's birth in Cody, as if the ghost of Buffalo Bill hovered over his cradle, but the truth is that he was ten months old when his parents left Cody for San Diego, California, and he never returned to the fabled town. He may, of course, have learned about its legendary past from his parents and brothers. The California and Arizona where he spent his childhood and youth were by no means the Wild West of imagination, but an unromantic land to which thousands of rootless, tight-knit American families like the Pollocks migrated in search of a better standard of living. Over the next fifteen years, LeRoy Pollock worked one mostly unsuccessful truck farm after another in Phoenix, Chico, Orland, and Riverside. The family was poor, and the Pollock brothers shared the farm chores, so that Jackson early developed a love of the earth, of open space, and of animals and growing things.

Historically dispossessed, rootless, and deeply Presbyterian, the Scotch-Irish in America were a hardy and itinerant lot. As they migrated West from the Ohio River Valley and the South, they brought with them an indestructible self-reliance and antinomian resistance to settled life that constituted a large (though perhaps unconscious) part of Pollock's ethnic inheritance. LeRoy Pollock's trade was listed on Jackson's birth certificate as "Stone mason and cement work,"[3] and his sons remembered him as a man who loved the land and working with his hands. The Pollocks were not church-going people, and Pollock's widow, the painter Lee Krasner, has recalled that his family, when she knew them, were "anti-religious. . . . Violently anti-religious."[4] Yet this very resistance to religion was itself a logical extension of the roots of the Presbyterianism they rejected, and not incompatible with a speculative interest in spiritual ideas. Equally "Presbyterian" was the serious concern in the Pollock family with high standards of personal worth and inner direction.

4. (*Self-Portrait*), c. 1930–33
Oil on gesso ground on canvas, mounted on composition board, 7¼ x 5¼ in.
Lee Krasner Pollock

LeRoy Pollock was a gentle, reticent man who appears to have felt keenly his lack of financial success, and to have cherished strong hopes for his sons' futures. His wife, an immensely capable woman who kept the family on its course, had artistic aspirations which she fostered in her children, all of whom later chose to pursue careers in the arts. Art was discussed at home; the Pollock brothers knew that there was advanced art in Europe and New York. Charles Pollock, the eldest, left home in 1922 to study at the Otis Art Institute in Los Angeles and work in the layout department of the *Los Angeles Times*, and he occasionally sent home copies of *The Dial*, the New York magazine of avant-garde art and literature. Although Jackson was only ten or eleven, he may have noticed the magazine's reproductions of School of Paris painting, and when Charles left in 1926 to study art with Thomas Hart Benton at the Art Students League in New York, Jackson was fourteen, and not too young to start thinking about his own future.

By all accounts Jackson was a restless, moody, and rebellious youth, hostile to institutional constraint. He went to Riverside High School in 1927 (where he made friends with Reuben Kadish, who later became a sculptor and painter), but soon thought of dropping out. His father encouraged him to stay in school, but Pollock finally did leave Riverside High in March 1928, expelled, it appears, over an argument with an ROTC officer. That summer his family moved into Los Angeles, and Pollock enrolled at Manual Arts High School, where he made other new friends, among them Philip Guston and Manuel Tolegian, whom he would know for the rest of his life. Frederick John de St. Vrain Schwankovsky, an art teacher at Manual Arts who considered himself a modernist and knew about Cézanne and Matisse, took Pollock under wing and introduced him to the semimystical ideas of theosophy and Krishnamurti (as well as to vegetarianism and extrasensory perception). Southern California was a seedbed of any number of small cults emphasizing Indian and Oriental religions and corresponding diet and health regimes. Pollock's interest in these suggests that he was searching not so much for a religion as for an experience of culture—a coherent interweave of beliefs, practices, and attitudes that would help him find himself and direct his energies. He thought a good deal at this time about the nature of the universe and the meaning of religion, and wrote about these to his father, who, working in Arizona, replied:

I think your philosophy on religion is O.K. I think every person should think, act & believe according to the dictates of his own conscience without to [*sic*] much pressure from the outside. I too think there is a higher power a supreme force, a Govener, a something that controls the universe. What it is & in what form I do not know. It may be that our intellect or spirit exists in space in some other form after it parts from this body. Nothing is impossible and we know that nothing is destroyed, it only changes chemically. We burn up a house and its contents, we change the form but the same elements exist, gas, vapor, ashes, they are all there just the same.[5]

At Manual Arts, Pollock's rebelliousness once again got him expelled, this time for publishing (with Guston and Tolegian) two broadsides called the *Journal of Liberty* , which vigorously attacked the adulation of athletics and "the consequent degradation of

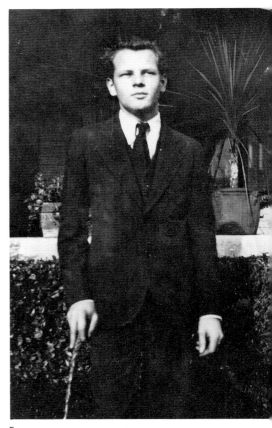

5

5. Jackson Pollock, c. 1929

scholarship. Instead of yelling 'hit that line,' we should say, 'make that grade.' Give those letters to our scholars, our artists, and our musicians instead of animated examples of physical prowess."[6]

Over the summer of 1929 Pollock worked with his father on a surveying and road-construction gang; in the fall he was readmitted to Manual Arts, only to be expelled soon again. Writing about this development to his brothers Charles and Frank, who were both now living and studying in New York, he mentioned that he had recently subscribed to two contemporary art magazines, *Creative Art* and *The Arts*, and added:

I have dropped religion for the present. Should I follow the Occult Mysticism it wouldn't be for commercial purposes. I am doubtful of any talent, so what ever I choose to be will be accomplished only by long study and work. I fear it will be forced and mechanical. Architecture interests me but not in the sense painting and sculptoring does. I became acquainted with Rivera's work through a number of Communist meetings I attended after being ousted from school last year. He has a painting in the Museum now. Perhaps you have seen it, Dia de Flores. I found the Creative Art January 1929 on Rivera. I certainly admire his work. . . .

As to what I would like to be. It is difficult to say. An Artist of some kind. If nothing else I shall always study the Arts. People have always frightened and bored me consequently I have been within my own shell and have not accomplished anything materially.[7]

Before his most recent expulsion Pollock had been taking clay modeling and a life class with Schwankovsky, with whose help he was now readmitted to Manual Arts on a parttime basis for the spring semester. He had an almost ideal schedule for a troubled and gifted young person, spending half the day taking classes in clay modeling and life drawing, the other half reading and working at home. On January 31, 1930, he wrote to his brother Charles that "i am continually having new experiences and am going through a wavering evolution which leave my mind in an unsettled state."[8] After mentioning the encouragement he was getting from his clay modeling class, he added that

my drawing i will tell you frankly is rotten it seems to lack freedom and rhythem [sic] it is cold and lifeless. it isn't worth the postage to send it . . . the truth of it is i have never really gotten down to real work and finish a piece i usually get disgusted with it and lose interest. water color i like but have never worked with it much. altho i feel i will make an artist of some kind i have nver [sic] proven to myself nor any body else that i have it in me.[9]

Despite his self-doubts, he was curious about the technical aspects of art, eager to receive criticism, advice, and book lists from his brothers. Frank and Charles returned to Los Angeles in June 1930, and Jackson went with Charles to see José Clemente Orozco's new fresco, *Prometheus*, at Pomona College. With two older brothers already established in New York, and his growing resolve to become an artist, Jackson's decision to accompany Frank and Charles when they returned to New York the following fall is hardly surprising. On September 29, 1930, the provincial but unparochial youth registered for Thomas Hart Benton's class—Life Drawing, Painting, and Composition—at the Art Students League, determined to find out whether "i have it in me," despite his reservations about his drawing and himself.

6

2 New York, 1930-41

The 1930s in New York, as far as art was concerned, was a restless, cantankerous, inchoate decade, slowly kindling what would eventually combust as postwar American painting. Since the Armory Show in 1913, which had introduced avant-garde (primarily French) art to a shocked and provincial American public, a pervasive modernist consciousness had taken hold without really sinking down roots into American soil. Through the teens and twenties, and in varying degrees, artists such as Arthur Dove, Georgia O'Keeffe, Edward Hopper, Charles Demuth, Charles Sheeler, and Ralston Crawford had done work that took into account the integrity of the picture plane, the materiality of the surface, and the underlying abstractness of form itself; yet, as Barbara Rose has pointed out, "There is almost no evidence that the analytic Cubist works of Braque and Picasso that were shown at the Armory Show were understood or imitated by American artists."[10] Max Weber assembled Cubist planes without essentially dissolving traditional references to objects, and John Marin fused, in his seascapes, a Cubist sense of shallow space with almost picturesque motifs. Few Americans were willing to explore the *logic* as distinct from the *look* of modernism, though among that few were Stuart Davis and Milton Avery. Davis, who championed American abstract art and American subject matter, deployed the formal language of Synthetic Cubism in his brightly hued celebrations of American urban vitality, while Avery, through an equally profound grasp of Matisse's color and drawing, arrived at a serene and personal vision of simplified, rugged natural forms.

Thus the young artist arriving in New York in the early 1930s would have found his attempts to unearth an American equivalent of high modernism (if that, in fact, was what he was looking for) frustrated by selective and idiosyncratic versions of that idea. There was as yet no homogeneous art world of artists and galleries, no strongly united group of artists, dealers, critics, and curators who felt it necessary to keep up with School of Paris developments. To make matters worse, the country itself was in miserable shape, the Depression becoming more acute every day. Even in prosperity artists had little chance of making a living by their work, and in hard times even subsistence living was a chancy

6. [*Camp with Oil Rig*], c. 1930-33
Oil on gesso board, 18 x 25⅜ in.
Mr. and Mrs. John W. Mecom

proposition. A general anxiety about the economic and political future of the country would furthermore have made the unapologetic aesthetic and cultural chauvinism of "American Scene" and "Regionalist" painting hard to resist. Its chief spokesmen—John Steuart Curry, Grant Wood, and Thomas Hart Benton—had declared modernism decadent and modernist techniques irrelevant to American concerns.

The Art Students League, when Pollock first registered there, was a bastion of American Scene and Regionalist painting. Such venerable American Scene painters as John Sloan, Kenneth Hayes Miller, and Yasuo Kuniyoshi taught there, but Thomas Hart Benton—Pollock's teacher—outdid them all in evangelical fervor. His faith in subject matter taken from the American heartland of pasture, field, harvest, and hoedown was oratorical and Emersonian, and all the more persuasive for Benton's own testimony that he himself had been snatched from the jaws of the modernist leviathan.

By the time of the Armory Show, Benton had already gone to Europe and returned home, and was working in the style of his friend, Stanton Macdonald-Wright, cofounder with Morgan Russell of Synchromism (a technique for composition by pure color, based on the way complementary colors influence each other). Macdonald-Wright believed that abstraction should be based upon forms idealized and abstracted from nature, including the forms of the human body, and Benton was to develop this idea later into a system of dynamic rhythms and tensions that he used to teach the analysis of figures and forms. When he lost interest in modernist experimentation, he turned instead to such Renaissance techniques as foreshortening, perspective, and chiaroscuro, but he held onto his system of form analysis. A man with a strong anti-intellectual streak, Benton came to revile his modernist associates, in particular Alfred Stieglitz, Marin, Marsden Hartley, O'Keeffe, and Dove, and to turn with a convert's zeal to romantic, nativist themes. Yet Benton remained far more of a modernist, in style, than he was ready to acknowledge. Soon after arriving at the League, Pollock did "action posing" for Benton, who, along with the Mexican muralist Orozco, was just beginning his "America Today" murals at the New School for Social Research. In Benton's monumental montages of innumerable physical actions—reaching, hoisting, dancing—Pollock would have seen a twisting, energetic plasticity that could come only from a direct engagement with the two-dimensionality of the picture surface.[11]

Benton was an affable man who liked to treat his students as equals and criticized their work only when asked. When Pollock first began studying with him, Benton later recalled, he was shy, and seemed to have little apparent talent in drawing, although Benton, sensing that he was "some kind of artist," encouraged Pollock's "intense interest" in art. In his figure classes Benton stressed "a search for anatomical sequences of form rather than the usual study of the model's appearance in terms of light and shade," and on seeing Pollock's analytic studies of the Old Masters was impressed by his student's color and his "intuitive sense of rhythmical relations."[12]

Pollock remained with Benton through the fall of 1932, and

during this time developed a strong sense of vocation, based in part, no doubt, on Benton's own fervent belief in the stature of the artist. In February 1932 he wrote to his father: ". . . I'm going to school every morning and have learned what is worth learning in the realm of art. It is just a matter of time and work now for me to have that knowledge apart [*sic*] of me. A good seventy years more and I think I'll make a good artist—being a artist is life its self— living it I mean."[13] Benton soon came to realize that while Pollock lacked abundant natural facility, he nevertheless had a true and extraordinary gift. Even after Benton left the League in December 1932 to undertake a major commission in Indiana, he and Pollock remained in contact. In the fall of 1933 Pollock began attending the Bentons' Monday night musical evenings and spent part of every summer from about 1934 through 1937 with them at their summer home on Martha's Vineyard. "You've the stuff old kid— all you have to do is keep it up,"[14] Benton wrote Pollock sometime before the spring of 1935. It was a crucial benediction, coming as

7. (*Woman*), c. 1930–33
Oil on the rough side of Masonite, 14⅛ x 10½ in.
Lee Krasner Pollock

7

8

9

it did from the man Pollock considered the most important painter in America. Pollock later wrote that "My work with Benton was important as something against which to react very strongly, later on; in this, it was better to have worked with him than with a less resistant personality who would have provided a much less strong opposition."[15]

Pollock's earliest known paintings date from his studies with Benton at the Art Students League. From the very beginning, they show four qualities that were to remain permanent in his work: assured totality of conception, dynamic rhythm, unfailingly articulate touch, and emphatic contrasts of light and dark. His impulses are linear and draftsmanly, yet his feeling for paint, for its heft and fluidity, is sensuous and painterly. It is not true that his drawing lacks facility, but simply that his whole tendency is toward atmospheric and interdependent rendering, rather than descriptive discreteness. An early landscape, [*Camp with Oil Rig*] , is nomi-

8. Sketchbook, c. 1933–38
Pencil on paper, 18 x 12 in.
Lee Krasner Pollock

9. Sketchbook, c. 1938–39
Pencil and colored pencil on paper, 14 x 10 in.
Lee Krasner Pollock

10. [*Two Landscapes with Figures*], c. 1934–38
Oil on linoleum, 8⅞ x 25⅛ in., irregular
Left image: 7¼ x 8½ in., irregular
Right image: 6 x 9¾ in., irregular
Jason McCoy

*Titling of works in this book follows the practice of the editors of the *Catalogue Raisonné*. Pollock's own titles are printed as published, recorded, or recalled, e.g., *The She-Wolf*. Titles that have become standard through usage and publication, but that are not Pollock's, are enclosed in parentheses, e.g., (*Self-Portrait*). Titles given to works by the editors for purposes of identification are enclosed in square brackets, e.g., [*Camp with Oil Rig*]. These are descriptive, not interpretive.

nally a Regionalist painting, but it is imbued with desolation and melancholy that are neither mythic nor illustrational. Curiously, the two slanting foreground "poles" may owe their existence to Benton's exercises in composition, but they also foreshadow the tilting verticals in such later works as [*Composition with Figures and Banners*] (c. 1934–38) and *Blue Poles* (1952).

Pollock's dramatic counterpoise of light and dark emerges in the small and haunting (*Self-Portrait*), in which the juvenile face is modeled in dark contours and scumbles of white and red tints. The expressionist intensity of Pollock's sensibility was nourished by the work of the Mexican muralists—Rivera, Orozco, and Siqueiros—whom he greatly admired, and Orozco's monumental approach to the figure is particularly telling in the nightmarish figure in (*Woman*). A number of Pollock critics have viewed the picture as a private allegory of the artist's family, in which the figures surrounding the woman are seen as satellites of the powerful mother, but in this, as in virtually all other questions of psychological interpretation, the informed viewer must draw his own conclusions.

Even after Pollock stopped his formal studies at the League in the spring of 1933, he continued to draw from life at its studios, and somewhat later, probably around 1937, took up, on his own, the serious study of El Greco. A sketchbook page shows pencil analyses of two El Greco paintings—the *Annunciation* and the *Coronation of the Virgin with Saints Peter, Paul, James and the Two Saints John*—and in these Pollock follows Benton's method of analysis to the point at which the forms become autonomous geometric complexes. By the late 1930s, Pollock's drawing could fully meet not only the demands of actual observation (he drew graceful figure and portrait studies at this time), but also, and more importantly, the pressing demands of the fertile repository of inner images that were beginning to break through with real urgency. A sketchbook page from 1938 or 1939 presents three tiers of arabesquing, serpentine, and spiky forms reminiscent of

10

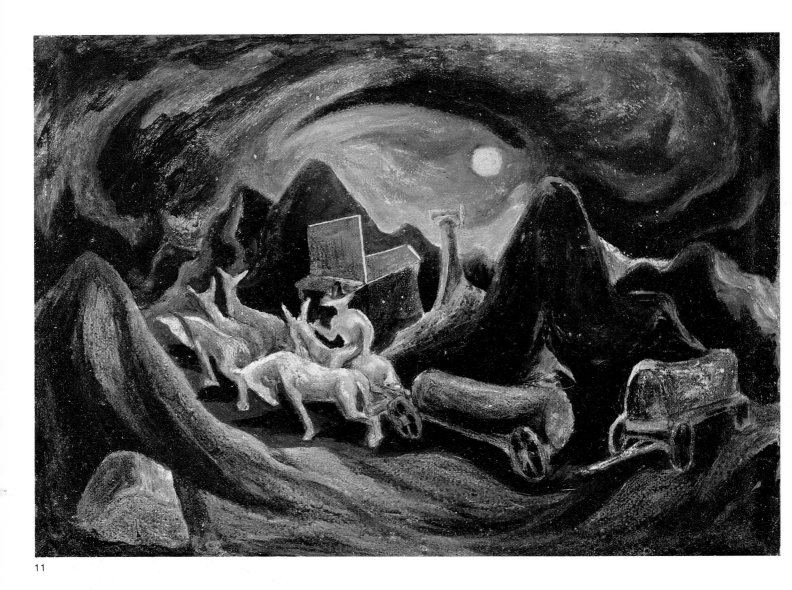

11

Orozco and Siqueiros but even more suggestive of an inexhaustible interior fund.

Other paintings made between 1934 and 1938, when Pollock was working independently, show him experimenting with a variety of structures and images. His predilection for paired images (which resurfaced many years later in *Portrait and a Dream*, 1953) appears for the first time in [*Two Landscapes with Figures*]. His continued interest in Regionalist motifs shows the influence of Albert Pinkham Ryder—the "only American master who interests me,"[16] Pollock was later to say—which is evident in the moonlit melancholy of *Going West*. Even this early, however, Pollock worked *against* his feeling as well as with it, and not every painting from this period was melancholy or turbulent. Pastoral peace informs [*Landscape with White Horse*], and other Western landscapes from this period are similarly smooth and undulant. Most surprising, as well, are two pictures that foreshadow the "all-over" compositions of the middle and late 1940s: *The Flame* and

11. *Going West*, c. 1934–38
Oil on gesso on composition board,
15⅛ x 20⅞ in.
National Museum of American Art, Smithsonian Institution, Washington, D.C.
Gift of Thomas Hart Benton

12. *(The Wagon)*, c. 1930–33
Oil on the rough side of Masonite, 10 x 13 in.
Lee Krasner Pollock

13. *The Flame*, c. 1934–38
Oil on canvas, mounted on composition board,
20½ x 30 in.
The Museum of Modern Art, New York

12

13

14

14 [*Composition with Figures and Banners*]. The surface of *The Flame* is extraordinarily prophetic with its lanceolate thrusts of red, white, and yellow and its interstitial play of dark and light, while the curvilinear clusters enclosing both figures and poles in [*Composition with Figures and Banners*] herald Pollock's later engagement

15 with repeating rhythms. Again in [*Overall Composition*] Pollock predicted not only his later radical development, but also indicated his concern for the role of the framing edge by including a selvage area at the lower margin to modify and arrest the allover distribution of strokes.

Pollock was not yet ready to move into complete abstraction, although a new degree of abstractness, exemplified in the intricate

16 interlockings of [*Panel with Four Designs*], entered the work of the middle-to-late 1930s. Other paintings hint at an incipient, if still incoherent engagement with Cubist composition, among them [*Composition with Cubic Forms*] (c. 1934–38), in which Pollock

situated rectilinear forms within a curvilinear surround.

When Pollock left the Art Students League in the spring of 1933, the Depression was at its height, with unemployment at twenty-five percent. The winter of 1934–35 he worked as a janitor at the City and Country School for ten dollars a week, which he shared with his brother Sanford, who had also come east. Food and fuel were scarce, and sometimes the two brothers stole to eat. In February 1935 Pollock found employment through the Emergency Relief Bureau as a stonecutter at $1.75 an hour; he earned his stipend cleaning Augustus Saint-Gaudens's statue of Peter Cooper in Cooper Square. Then, in August of that same year, he was given work with the mural division of the newly created Federal Art Project of the Works Progress Administration, joining the easel division sometime in 1936. The Project required him to submit one painting about every four to eight weeks. These works were intended for public buildings, and Pollock could select his own subject matter and work in his own studio for an average monthly wage of $91.50.

Pollock was to remain with the FAP, with certain interruptions, until Roosevelt closed it down in early 1943. The support and stability it gave him were inestimable, as they were for other artists employed by the Project, including Gorky, de Kooning, Gottlieb, Ad Reinhardt, and Rothko. For the first time, American artists were paid professionals (never mind at how low a stipend) whose work received government endorsement. WPA-sponsored classes and exhibitions as well as a new sense of community fostered talk and mutual awareness, and New York artists suddenly began to have a fertilizing self-consciousness of their common difficulties and aims. Pollock, who was never much of a "joiner," nevertheless found himself part of a small, youthful, energetic, and increasingly ambitious enclave that gradually began to share a sense of mission.

The middle 1930s brought him other important new experiences as well. In the spring of 1936 he joined the "experimental workshop" Siqueiros had recently established on Union Square. Siqueiros encouraged experimentation with new materials and techniques for its own sake. He was interested in the use of spray guns and airbrushes, and the latest synthetic paints and lacquers, Duco among them, as well as in the idea of the "controlled accident" and the direct, spontaneous application of paint. This atmosphere of free, open exploration and experimental curiosity about technical matters must have stimulated Pollock's own practicality and inventiveness, for he was always to have a matter-of-fact unorthodoxy about materials.

Another crucial element in Pollock's growth during the late 1930s was the availability of first-rate examples of contemporary European painting in New York museums and galleries. No serious young painter would have failed to see two crucial shows at the Museum of Modern Art: *Cubism and Abstract Art* in 1936, and *Fantastic Art, Dada, Surrealism* in 1936–37. Pollock would have seen Surrealist shows at the Julien Levy Gallery and nearly annual exhibitions of André Masson and Joan Miró at the Pierre Matisse Gallery. Matisse's 1916–17 masterpiece, *Bathers by a River*, could be seen at Curt Valentin's, Kandinsky was on view at the Museum

14. [*Composition with Figures and Banners*], c.1934–38
Oil on canvas, 10⅝ x 11¾ in.
Lee Krasner Pollock

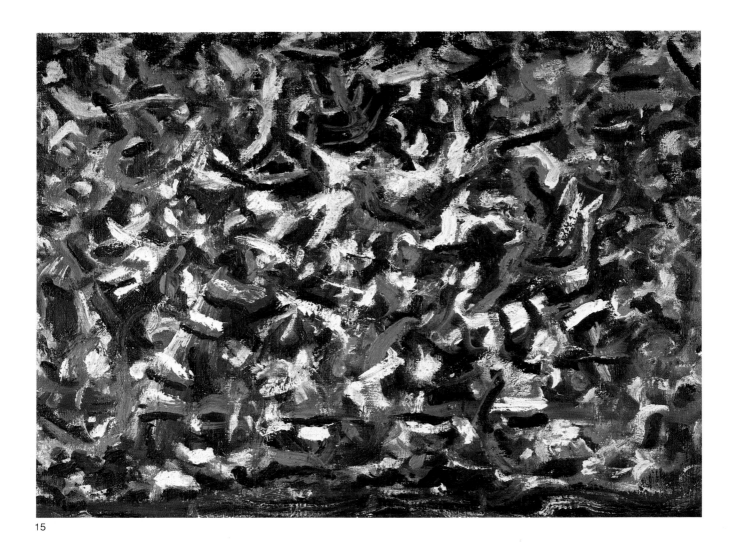

15

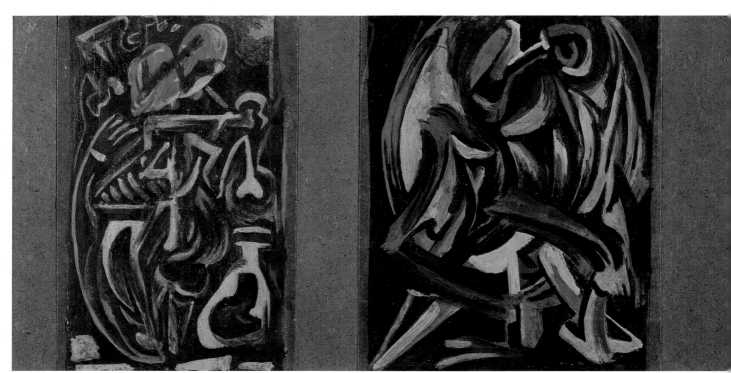

16

of Non-Objective Painting (founded 1937), and abstract art was to be seen at the Valentine Gallery and the Pinacotheca. Equally important was the arrival of European artists in America, including John Graham, who was to have an important influence on Pollock—as important, in fact, as Benton's.

Born in Kiev with the name Ivan Dambrowsky, Graham had served as a cavalry officer in World War I. After supporting the counterrevolutionaries in the Crimea, he fled, in 1920, after their cause failed, first to France and then to America, where he studied at the Art Students League. He was a superbly educated and cultivated man, with a rich network of friendships among both the Russian and the Parisian avant-garde. In New York he made a point of befriending young, unknown artists (among them Gorky and David Smith), and explicating the principles of Cubism to them. He believed in an art whose source, as he wrote in his *System and Dialectics of Art*, was "the immediate, unadorned record of an authentic intellecto-emotional REACTION of the artist set in space. . . ."[17] This reaction was to be embodied in the variations in brush pressure and stroke—in all the physical acts that the medium could register. Graham thus anticipated the principles of Abstract Expressionism, especially the value ascribed to the artist's gesture, which he called "automatic 'écriture.'"[18]

Above all, Graham, who was familiar with the doctrines of both Freud and Jung, valued the role of the unconscious in art. In "Primitive Art and Picasso," an article he published in the April 1937 issue of *Magazine of Art*, he stated that "The unconscious mind is the creative factor and the source . . . of power and of all

15. [*Overall Composition*], c. 1934–38
Oil on canvas, 15 x 20 in.
Lee Krasner Pollock

16. [*Panel with Four Designs*], c. 1934–38
Oil on the smooth side of Masonite, 7¾ x 27 in.
Lee Krasner Pollock

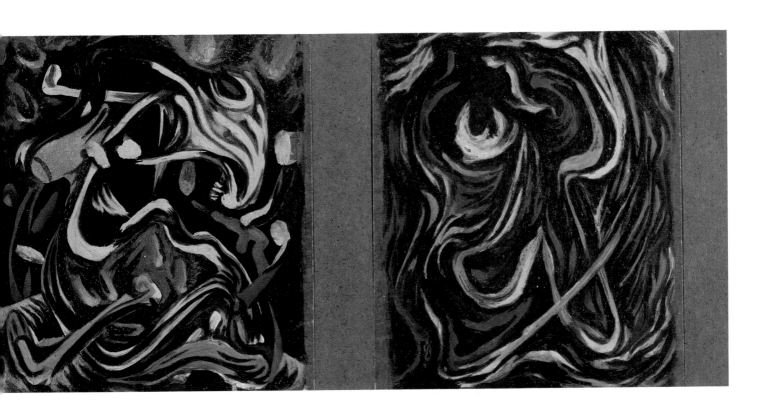

knowledge, past and future,"[19] and claimed that in exploring primitive art, Picasso had gained access to the unconscious in its function as the storehouse of racial memory (a concept akin to Jung's theory of the collective unconscious). Pollock was so impressed by this article that he wrote to Graham, who then got in touch with him. Graham liked Pollock's work and intended to add his name to a list of promising young American artists for a second edition of *System and Dialectics of Art*. Probably through Graham, but also because Picasso was very much on the minds of many young artists (including Gorky, de Kooning, and Lee Krasner) determined to paint their way out of the persistent provinciality of even the best American modernist work, Pollock became thoroughly engrossed with Picasso as the 1930s drew to a close. Graham was a catalyst; Picasso was a *cause*, in the sense of being a force that mobilized all of Pollock's competitive ambition.

It was less the Analytic Cubist Picasso than the more recent Synthetic Cubist, Surrealist, and Expressionist Picasso that interested Pollock, at least at first. While the influence of Siqueiros and Orozco was still strong—as in the large violent forms of [*Naked Man with Knife*]—Picasso represented a completely fresh vocabu-

18

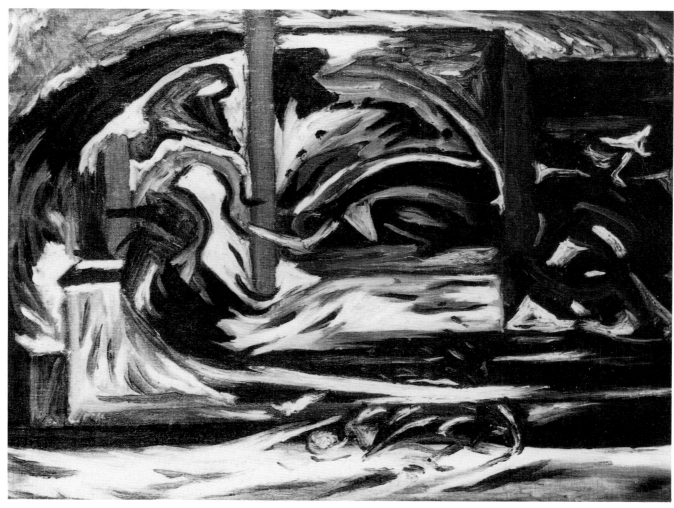

17

lary of distorted, fragmented, and primitive forms, and a new, supremely sophisticated way of creating an expressively packed picture out of the shallow, planar space ultimately derived from the grid of Analytic Cubist infrastructure. The bull's head in [*Man, Bull, Bird*] may well be a remnant from Pollock's earliest Western motifs, but it has changed continents, so to speak, for it resembles nothing so much as Picasso's 1934 *Bullfight*. Unquestionably (*Head*) signals Pollock's awareness of Picasso's Minotaur images, which could be seen (along with Masson's Minotaur images), in New York exhibitions of the late 1930s and early '40s and were often reproduced in such magazines as *Cahiers d'art* and *Minotaure*. The proliferation of *eye* images in Pollock's paintings suggests that he had become thoroughly conversant with Surrealist iconography, in which the eye plays an important symbolic role as the point of convergence between the inner and outer worlds. The influence of primitive art, primarily American Indian, as well as Pollock's engagement with Miró, can be seen in *Bird*, while other paintings from this 1938–41 period teem with serpents, skulls, female images, and plant and animal forms. It is as if Pollock vacuumed up whatever he saw—Jungian symbols, American Indian motifs, whatever shapes and images that sifted in fragments through his memory—with a mighty suction that fused them with his own incessant creation of images. *Birth*, for instance, seems to be a synthesis of both derived and invented images that resist clear meaning. The painting's title has encouraged some critics to search for a sexual, feminine imagery, and at least one Jungian critic identifies the cylindrical passage at the lower right as a birth canal.[20] But it is almost impossible to say, on the basis of the painting itself, just what the forms depict, or if they depict anything at all. Pollock's titles, in general, remain mysterious, allusive, and private. We cannot say with any certainty what they refer to. Sometimes descriptive, sometimes poetic, they elude interpretation while suggesting the rich powers of association Pollock brought to the making of the paintings themselves.

Most of the recent Jungian interpretation of Pollock's 1938–41 paintings[21] does not, in fact, derive from facts about the paintings, but from the implications of the following biographical facts. Sometime in 1937 Pollock, who since adolescence had had a history of alcoholism, spent several months in psychiatric treatment—not, however, with a Jungian. He then entered the Westchester Division of the New York Hospital in June 1938, for treatment of acute alcoholism, and remained there until September. His psychiatrist, Dr. James Wall, was an eclectic who drew upon the spectrum of psychoanalytic theory, including Freud and Jung, without specifically advocating one approach over another. Early in 1939 Pollock began psychoanalysis with a Jungian, Dr. Joseph Henderson, continuing treatment through the summer of 1940, at which point Dr. Henderson moved to San Francisco. Pollock then found another Jungian analyst in the spring of 1941, Dr. Violet Staub de Laszlo, with whom he remained in treatment through 1942 and probably some part of 1943.

By all accounts, Pollock, who was not inherently nonverbal, nevertheless found it difficult to talk, particularly about his own

17. [*Composition with Vertical Stripe*], c. 1934–38
Oil on canvas, 22½ x 30 in.
Lee Krasner Pollock

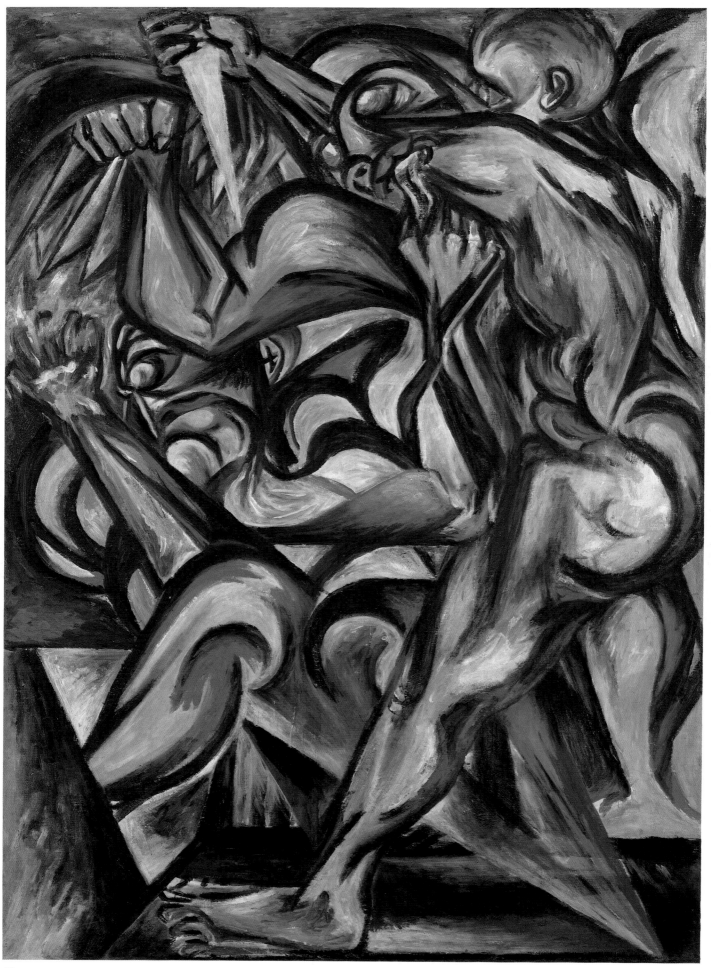

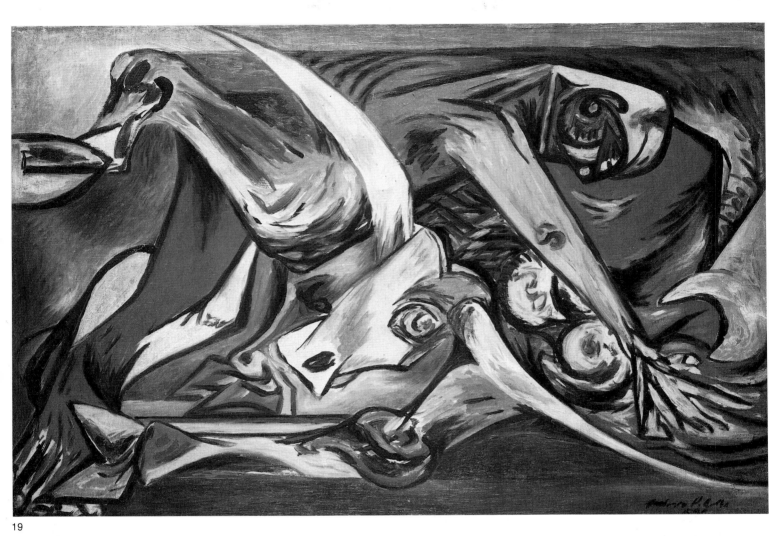

19

18. [*Naked Man with Knife*], c. 1938–41
Oil on canvas, 50 x 36 in.
The Tate Gallery, London
Gift of Frank Lloyd

19. [*Man, Bull, Bird*], c. 1938–41
Oil on canvas, 24 x 36 in.
The Anschutz Collection

20

conflicts, and he offered to show his works on paper to his analysts as a way of facilitating treatment. These are now known as the "psychoanalytic drawings," although to what extent he made the drawings for the purposes of treatment remains unclear. At the beginning he brought in what might simply be called working drawings; but analysis usually involves a transference relationship, and given the current absence of information concerning Pollock's possible transference to his analysts, it is difficult to know what specific analytic themes (if any) the drawings may contain, or, indeed, whether the drawings were eventually done specifically *for* the purposes of analysis. One is color coded to Jungian notions of

intuition, thinking, feeling, and sensation, but its specificity is unusual. Both of Pollock's Jungian analysts have stated that they avoided theoretical talk with him: "My treatment was supportive and I did not consciously discuss Jung or Jungian theories with him," Dr. Henderson has said, and Dr. Laszlo has similarly commented, "We rarely discussed abstract concepts; nor do I recollect discussing archetypes since I wished to avoid intellectualization. . . ."[22] Both doctors did speak of cycles of psychic birth, death, and rebirth, a central concept in Jungian psychology, but Dr. Laszlo has said that she considered the images in Pollock's drawings to be "autonomous" upwellings from the unconscious, and not particularly explicable in Jungian terms.[23] On his own, of course, Pollock may have delved into Jungian theory, which, along with Freudian theory, was very much "in the air" at the time, even to the point of being inescapable in conversation with other artists. But as art historian Donald E. Gordon has said, "The service that Henderson and de Laszlo performed for Pollock was that they *encouraged* him to accept the babblings and doodlings of his unconscious as a part of his personal identity and ineluctable fate as an artist."[24] When, many years later, Pollock declared that he had "been a Jungian for a long time,"[25] he seems to have been emphatically confirming this acceptance of the unconscious, rather than signaling his allegiance to Jungian dogma as such.

In the long run, Jungian interpretations of Pollock's work, and indeed any psychologically oriented interpretations, tend to be minimally verifiable and mostly self-confirming. Such readings miss the developmental complexities of Pollock's extraordinary struggle, in the late 1930s and early '40s, to assimilate important external influences (chiefly from the School of Paris) into tumultuous interior energies that sorely needed direction. The paintings from this period are frequently imperfect and awkward, and show evidence of aesthetic hard work. It was no easy process for Pollock to confront his major and still-very-much-alive precursors Picasso and Miró, and to absorb the Surrealist doctrine of psychic automatism. "I once asked Jackson Pollock if he had ever been influenced by the Surrealists. . . ." critic-dealer John Bernard Myers has written. "He said yes, in one way: their belief in 'automatism' or making a picture without 'conscious' control of what would happen on the canvas before beginning one. He felt that Masson in particular had obtained some happy results utilizing 'automatism.'"[26] Pollock would have heard about this doctrine from other artists, and read about it in such magazines as *Minotaure* and *View*, where he would also have seen pictures of masks and totems and read about myths—another popular subject of the day. He would have seen *Guernica* at the Valentine Gallery in 1939 and other Picassos at the large Picasso exhibition that year at the Museum of Modern Art.

Pollock's "psychoanalytic" drawings are important because they show his evolution toward a formal and iconographical lexicon that took all of these disparate influences into consideration. His later synthesis of major modernist currents came out of this earlier exploratory and synthetic work. Already, in many of these drawings Pollock distributes individual shapes in a proto-"allover"

20. *(Head)*, c. 1938–41
Oil on canvas, 16 x 15¾ in.
Lee Krasner Pollock

24

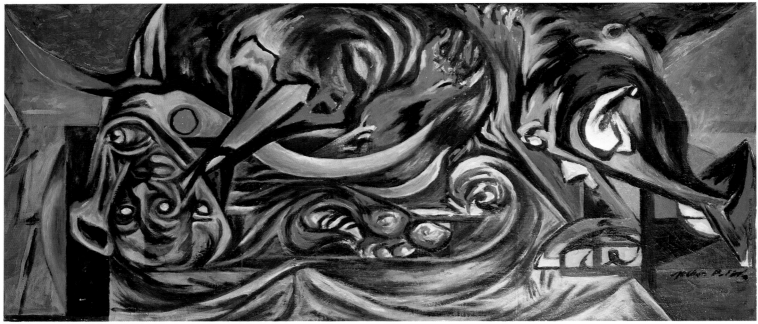

21

22

21. [*Composition with Donkey Head*],
c. 1938–41
Oil on canvas, 21⅞ x 50 in.
Lee Krasner Pollock

22. *Bird*, 1941
Oil and sand on canvas, 27¾ x 24¼ in.
The Museum of Modern Art, New York
Gift of Lee Krasner in memory of Jackson Pollock

23. *Birth*, c. 1938–41
Oil on canvas mounted on plywood, 46 x 21¾ in.
The Tate Gallery, London
Lent by Lee Krasner Pollock

24

composition. The shapes themselves make up a repertoire of re-membered and invented details: the mandala, the crescent, the circular complex, the semihuman monster, the sharply horned mask, the daggerlike tongue—all of them recurring frequently in other drawings of this period. Rosalind Krauss has pointed out their resemblance not only to American Indian and African tribal motifs, but also to the iconography of *Guernica* (and studies for *Guernica*), which had horse and bull images as well as a severed warrior's head and both a horse and a woman with daggerlike tongues. What happens, for instance, in the animal-human complex in the lower center of Pollock's drawing happens constantly throughout his drawings, where, as Krauss puts it, "one faces a configuration in which areas of figure get reconverted into ground for new, yet more autonomous pieces of figuration, they in turn becoming ground for further figures."[27]

Whatever the drawings' psychic content, their formal task was to exercise Pollock's need for the *interconversion* of form, the protean transmutation of figuration into abstraction and vice versa. This process can also be seen in the paintings of the period: [*Com-*

26

24. Drawing, c. 1939–40
Pencil and colored pencil on paper, 13 x 10¼ in.
Maxwell Galleries, San Francisco

25. [*Naked Man*], c. 1938–41
Oil on plywood, 50 x 24 in.
Private collection

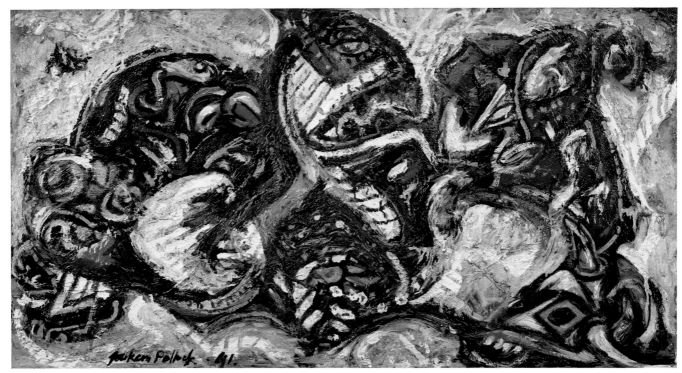

26

position with Masked Forms], for example, which foreshadows
91 the emergence and retreat of figuration in much later work (*Ocean Greyness*, 1953, comes to mind) and begins to act out this dialectic in an open atmospheric space. The same process takes place in
27 (*White Horizontal*), in which elliptical, curvilinear, and involuted forms become attenuated, and fibrous linear branchings break through a white "cover" to imply extended and submerged shapes. At the same time Pollock continued to pursue relatively clear-cut
25 figuration, as in [*Naked Man*], in which the Picassoid figure solidly planted in shallow vertical space possesses, instead of a face, a beaked mask with intricate detailing resembling the circular forms in *Birth*.

As independent as Pollock was—and he belonged neither to the American Abstract Artists group nor studied at Hans Hofmann's school—he was as yet unwilling to abandon figuration for abstraction, though he had taken abstraction very far by the early 1940s. His aesthetic problem was precisely the one Clement Greenberg has described in his reminiscence of the period:

Looking back, I feel that the main question for many of the painters I knew was how much personal autonomy one could achieve within what began to look like the cramping limits of Late Cubist abstraction. To depart altogether from the Cubist canon seemed unthinkable. And it was as if the answer or solution had to wait upon a more complete assimilation of Paris. Not that Paris was expected to deliver the whole answer, but that New York had to catch up with her in order to collaborate in delivering it.[28]

Pollock, in other words, still had to work his way through Cubism, and not just late Cubism, but the underlying principles of Analytic Cubism. There could be no evasion of its grip on the

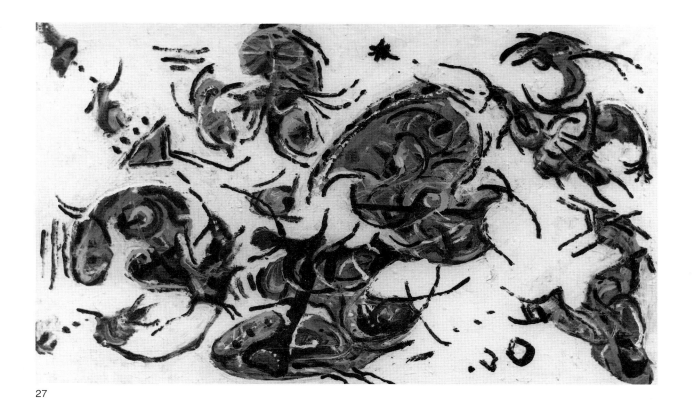

27

picture plane, its radical dismantling of illusion, and its loosening of the rigidities of fixed, hierarchical form.

For Pollock, the commitment to ongoing psychological exploration and artistic growth was tumultuous and unsettling. In the summer of 1940 he wrote to his brother Charles, "I haven't much to say about my work and things—only that I have been going thru violent changes the past couple of years. God knows what will come out of it all—it's pretty negative stuff so far."[29] A year later, in July 1941, while Pollock was still in Jungian analysis, his brother Sanford, with whom he lived, wrote to their brother Charles about Jackson's chronic emotional difficulties, but added that

on the credit side we have his Art which if he allows to grow, will, I am convinced, come to great importance. . . . he has thrown off the yoke of Benton completely and is doing work which is creative in the most genuine sense of the word. Here again, although I "feel" its meaning and implication, I am not qualified to present it in terms of words. His thinking is, I think, related to that of men like Beckman[n], Orozco and Picasso. We are sure that if he is able to hold himself together his work will become of real signifigance.[sic] His painting is abstract, intense, evocative in quality.[30]

Pollock had worked his way, by 1941, up to a breakthrough into major painting. And a breakthrough, in fact, is just what followed.

26. [*Composition with Masked Forms*], 1941
Oil on canvas, 27¾ x 50 in.
Private collection

27. (*White Horizontal*), c. 1938–41
Oil on canvas, 22 x 36½ in.
Private collection

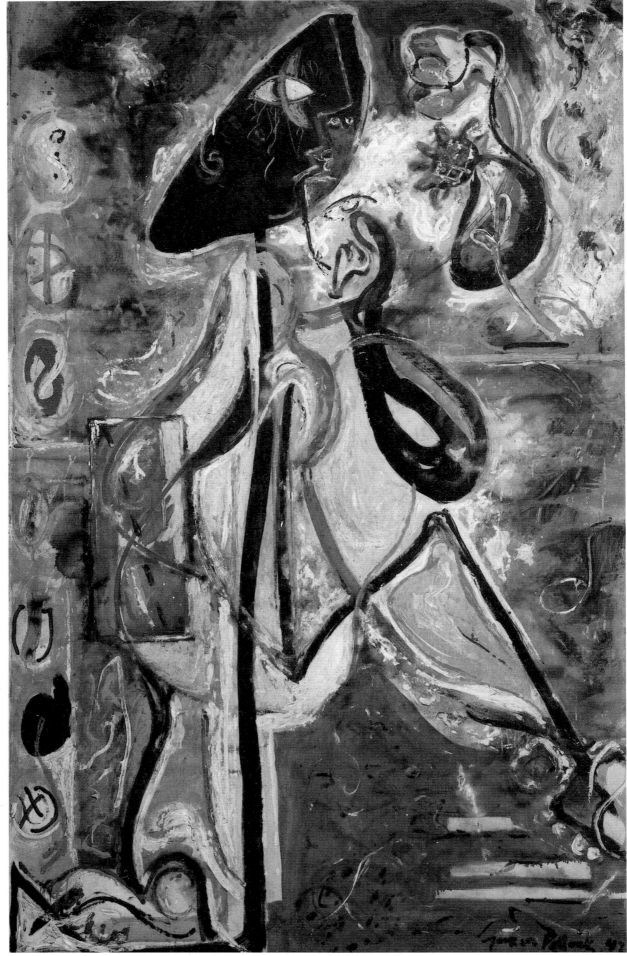

3 Arrival, 1942–46

In November 1941 John Graham invited Pollock to participate in a show to be held at McMillen Inc. the following January, and to include, in addition to paintings by Picasso, Matisse, Braque, Bonnard, and Modigliani, works by both known Americans such as Stuart Davis and Walt Kuhn, and unknown ones, among them Pollock, de Kooning, and Krasner. Hearing that Pollock lived just around the corner from her, Krasner looked him up, thus beginning a relationship that would last until Pollock's death. It was through Krasner that Pollock began to meet other artists of his generation. According to her, the Chilean painter Matta instructed William Baziotes to get Robert Motherwell to meet Pollock in order to invite him to take part in a major Surrealist exhibition.[31] Pollock refused on the grounds that he didn't like "group activity,"[32] although he told Motherwell that he had been convinced for some time of the role of the unconscious in art. Pollock, Motherwell, and Baziotes became friends, spending several evenings together with their wives and Lee Krasner, experimenting with writing automatist poetry.

Pollock respected and trusted Krasner's aesthetic judgment; Krasner, when she first saw the paintings in Pollock's studio, was astounded at their quality. Pollock was making fully mature, fully realized works of art, and what was more, he knew it. His assurance, at times, was indomitable. When Krasner brought Hans Hofmann to see Pollock's work for the first time, he remarked that Pollock "worked from the heart," but suggested that he might do well to enroll in his school and work from nature—to which Pollock replied, "I am nature."[33] And at a later meeting, after Hofmann had expended considerable breath in explaining the principles of painting, Pollock burst out, "Your theories don't interest me—put up or shut up! Let's see your work."[34]

Pollock had good reason to be arrogant. Despite his consuming WPA duties, he painted three works in 1942 that constitute his arrival at major painting. To begin with, they were larger than any of his previous paintings, which, up to this time, had never exceeded fifty inches. But *The Moon-Woman* is 69 x 43 inches; *Male and Female* is 73 x 49 inches; and *Stenographic Figure* is 40 x 56 inches. This expanded scale permitted Pollock to situate big, mytho-

28. *The Moon-Woman*, 1942
Oil on canvas, 69 x 43 in.
The Peggy Guggenheim Collection, Venice
The Solomon R. Guggenheim Museum, New York

28, 29

30

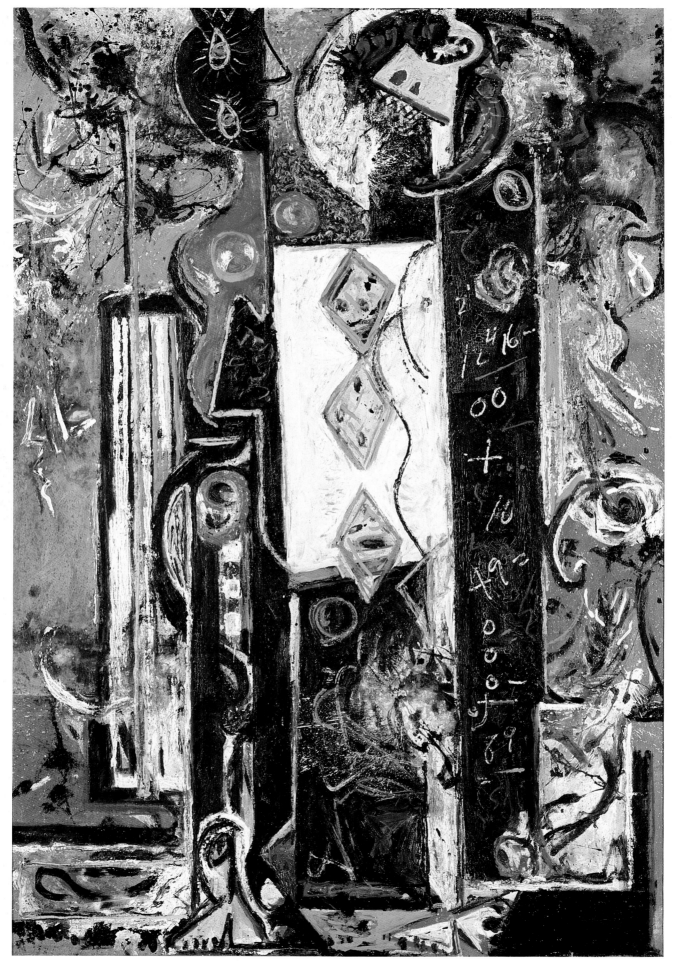

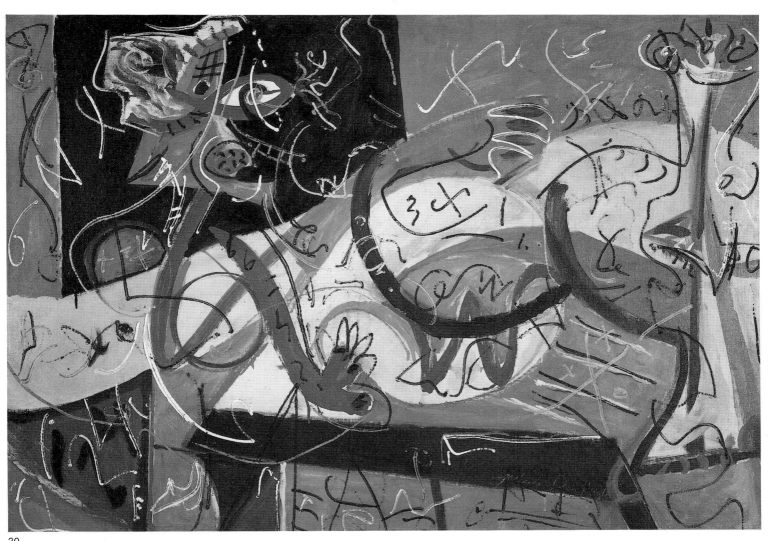

30

29. *Male and Female*, c. 1942
Oil on canvas, 73 x 49 in.
Philadelphia Museum of Art
Partial gift of Mrs. H. Gates Lloyd

30. *Stenographic Figure*, c. 1942
Oil on canvas, 40 x 56 in.
The Museum of Modern Art, New York
Mr. and Mrs. Walter Bareiss Fund

poeic figures in a plastic, ambiguous, and increasingly abstract space. The rectilinear subdivisions of *The Moon-Woman* become autonomous zones for painterly marking, while the curvilinear stick figure with its crescent-shaped head, double-crescent eye, and thin, undulating "body" appears to draw the picture toward a center and at the same time push it away. In *Male and Female*, Pollock created one of his first masterpieces, a painting of extraordinary ambiguity-within-order. Surrealism and Cubism mesh as the two totemic figures function simultaneously as images and as vertical planes in a sequence of such planes establishing the picture's rectilinear flatness. The images themselves could not be more tantalizing: that on the left appears to be female, having breasts and possibly a bulging womb; that on the right less certainly appears to be male, although a clear sexual identity for either figure remains elusive. The title does not clear the matter up, since it is possible to see male and female attributes in each of the figures. Passage yields to passage in an enriched virtuoso vocabulary of spatters, drips, swirls, scumbles, gestures, arabesques, filled-in shapes, and inscribed numbers, hieroglyphics of a painterly calligraphy that, for all its energy, never crowds or squeezes the picture.

In 1943 Pollock met the collector Peggy Guggenheim, who had recently returned to New York to escape the war in Europe. For Pollock it was a timely encounter. Since the termination of the WPA, he had first found piecework in a sweatshop painting neckties and decorating lipsticks, and had then worked as a custodian at the Museum of Non-Objective Painting on Fifty-fourth Street. Peggy Guggenheim exhibited a collage that Pollock and Motherwell had worked on together at her museum-gallery, Art of This Century, on West Fifty-seventh Street, and showed *Stenographic Figure* (with its very Picassoid reclining figure) in her *Spring Salon for Young Artists*. Later that year she gave him a year's contract, and a one-man show—his first—in November. Clement Greenberg, reviewing the show in *The Nation*, wrote of the "surprise and fulfillment in Jackson Pollock's not so abstract abstractions," and

31 his arrival, in both *Male and Female* and *The Guardians of the Secret*, at a scale somewhere "between the intensity of the easel picture and the blandness of the mural. . . ." And he concluded that having "gone through the influences of Miró, Picasso, Mexican painting, and what not," Pollock had "come out on the other side at the age of thirty-one, painting mostly with his own brush."[35]

Pollock had indeed transcended his influences and come into his

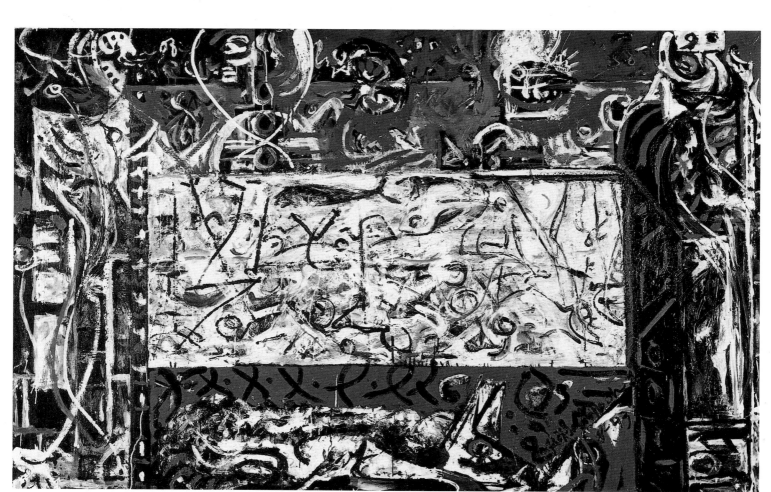

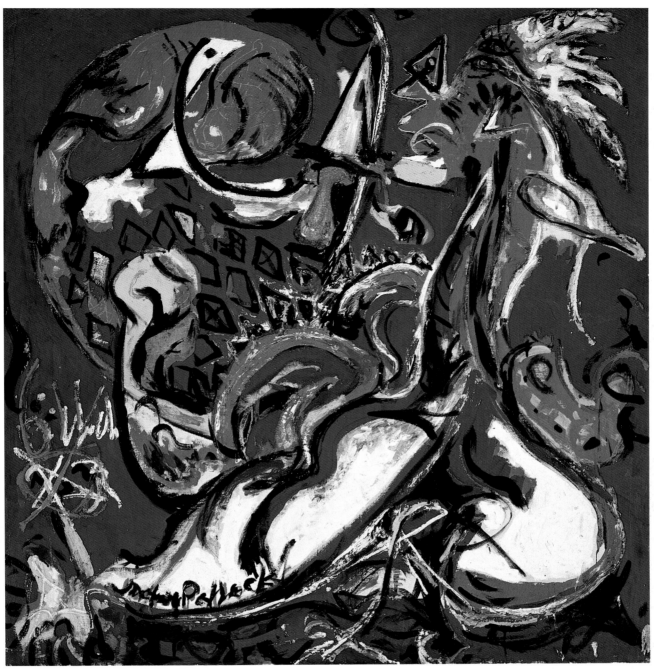

32

31. *The Guardians of the Secret*, 1943
Oil on canvas, 48¾ x 75 in.
San Francisco Museum of Modern Art
Albert M. Bender Collection
Albert M. Bender Bequest Fund Purchase

32. *The Moon-Woman Cuts the Circle*, c. 1943
Oil on canvas, 42 x 40 in.
Musée National d'Art Moderne, Centre Georges
Pompidou, Paris
Gift of Frank Lloyd

own. His paintings were profoundly original in feeling, strangely ambiguous in form. In an interview conducted many years after Pollock's death, Lee Krasner pointed out that many of his abstract paintings "began with more or less recognizable imagery—heads, parts of the body, fantastic creatures. Once I asked Jackson why he didn't stop the painting when a given image was exposed. He said, 'I choose to veil the imagery.'"[36] She has since said that "when we had that discussion, it was in reference to *Guardians of the Secret*."[37] Whether Pollock meant it in relation to other paintings cannot be known. Certainly *Guardians of the Secret* is simultaneously highly figural and highly abstract. Like *Male and Female*, it has two vertical figures, in this case flanking a central panel

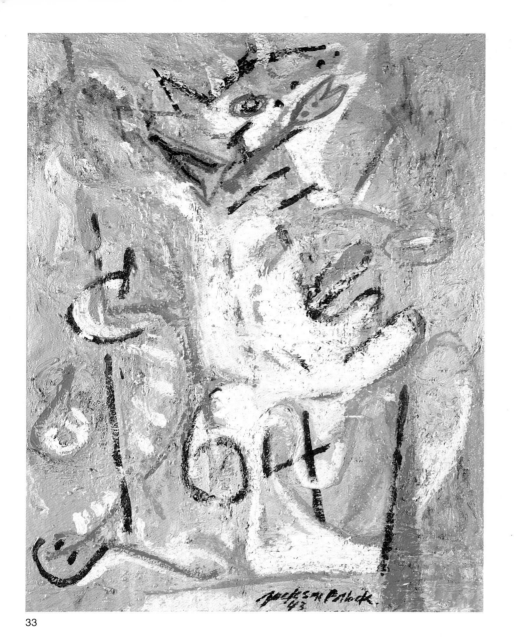

33

34

filled with hieroglyphs distributed in an "allover" style. In the painting's lower register Pollock inserted a dog—a symbolic watch-dog, perhaps, serving along with the vertical figures quite literally as the "guardian" of the painter's psyche, embodied by the central panel.[38] Yet the painting's near symmetry and balance once again bring *Guernica* to mind. It also has two vertical figures (the bull to the left, the woman with upstretched arms on the right) flanking a central area of roiling geometries, and from its example Pollock may well have understood the possibility of containing the turmoil of expressionist imagery within the formality and restraint of recti-linear planes.

There was no repetition in the 1943 Guggenheim show, and no tentativeness. Each painting was a complete, autonomous state-ment, and the show as a whole spoke for the protean inventiveness that Pollock could now exercise without limit. In *The Moon-Woman Cuts the Circle*, for instance, the boldness of the painterly

32

33. *Wounded Animal*, 1943
Oil and plaster on canvas, 38 x 30 in.
Private collection

34. *Pasiphae*, c. 1943
Oil on canvas, 56⅛ x 96 in.
The Metropolitan Museum of Art, New York
Purchase

image creates a powerful contrast with the ambiguity of the image's possible meaning; who or what the "moon-woman" is and what she is doing remain utterly mysterious.[39] The blue ground that the curvilinear shapes inhabit has been released from the planar flatness of Cubist space so as to imply (as in many of Miró's paintings) a nonspecific, highly abstract color atmosphere—a perfect medium for the purely painterly suspension of images. Yet this immateriality of ground disappears altogether in the poignant *Wounded Animal*, whose oil and plaster surface permits the inscription of the figure in a style reminiscent of prehistoric cave painting, examples of which Pollock may well have seen in the 1937 Museum of Modern Art show, *Prehistoric Rock Pictures in Europe and Africa*.

The Guggenheim show revealed, in sum, the astonishing, instinctive *rightness* of Pollock's aesthetic decisions. He secured his images well within the framing edges he consistently managed to take into

33

35

account, so that the surface, no matter how densely worked with pigment, remained essentially a fictive space—a space of mytho-poeic illusion—even as Pollock explored modernism's dismantling of illusionistic convention. In *Pasiphaë*, a painting that O'Connor and Thaw date from 1943, but that was shown for the first time in a group exhibition at Art of This Century in the spring of 1944, mythopoeic fecundity and the scrabble of painterly figures and marks exist in complete interdependence, giving the surface a re-pleteness hitherto implicit in Pollock's pictorial conceptions but now encouraged to a new and complex explicitness. Pollock, who seems more often than not to have titled his paintings only *after* he painted them, originally planned to call the work *Moby Dick*, after Melville's novel, which he greatly admired. But he changed his mind after James Johnson Sweeney told him the story of Pasiphaë, the Moon Goddess of Cretan myth who fell in love with the white bull Poseidon had sent to her husband, King Minos of Crete. She somewhat ingloriously secreted herself inside the body of a hollow wooden cow in order to consummate her passion, the issue of which was the Minotaur (focus of so much Surrealist symbolism)—

34

35. [*Composition with Pouring II*], 1943
Oil and enamel on canvas, 25 x 22⅛ in.
Hirshhorn Museum and Sculpture Garden,
Smithsonian Institution, Washington, D.C.

a creature with a human body and a bull's head. We cannot know Pollock's specific, personal associations to either Moby Dick or Pasiphaë, although common to both stories are themes of power and sexuality, of angry kings and monsters that devour and destroy.

Pollock's desire to "veil" his imagery seemed to increase in 1943, the same year in which it became most clearly defined, and he began to experiment with pouring paint in rivulets over relatively discrete shapes. Though one of his earliest efforts in this direction, [*Composition with Pouring*], has little of the complex structure of the later "poured" paintings, its runnels of black and white paint disrupt the larger yellow and red areas and enact the instantaneous conversion of what had been figure into ground. Pollock went on, in the majestic syncopations of *Mural*, to explore not so much the properties of pouring and dripping (although the painting shows some evidence of the technique) but rather the large sustained rhythms of the "allover" style, of which this is the first major statement. Commissioned by Peggy Guggenheim for her New York townhouse and painted in a single session either late in 1943 or early in 1944, the painting, at 7 feet 11¾ inches by 19 feet 9½ inches, was the largest Pollock had yet made, an absolute break with the easel, and an appropriation of the mural for the purposes of heroic abstraction, not thematic illustration. The thin vertical curves of the painting never achieve closure as figures, but wind through the painting in a way that collapses the distinction between painting and drawing—the issue that remained central to Pollock for the rest of his life.

Pollock's 1944 and 1945 paintings continued to explore the possibilities of alloverness without making a full commitment to pouring. His handling became, if anything, even more calligraphic, with *Night Mist* aswirl with clusters of automatic "handwriting" as well as drawn shapes. Pollock also began to distribute shapes within the canvas much as he had done in his "psychoanalytic" drawings, that is, in alignment with an invisible grid. This is done in a curvilinear and angled fashion in *Gothic* and more radically—because more fragmentedly—in *Night Ceremony*, where each individual drawn shape exists independently in its own spatial interval. He worked in sgraffito techniques in this period as well, increasingly fragmenting forms, yet drawing fantastic biomorphic images that moved toward an attenuation of line so delicate as to be almost weightless. He also worked through older ideas, making allover drawings of discrete shapes and continuing to explore Picassoid figuration, as he had done in one 1943 drawing showing two rounded figures engaged in some form of ambiguous sexual congress. Paintings in the 1944 [Equine series] show Pollock's fascination with the equine imagery in Picasso's bullfight paintings.

Pollock was working in a major style of increasing abstraction, but this is not to say that every painting was a success. Some paintings were provisional, some unresolved. Yet two paintings from his second one-man show at Art of This Century in the spring of 1945 represent, between them, fully achieved solutions to the problems of abstract figuration, fragmentation, and the productive tension between drawing as closed shape and drawing

36

37

41

38

36

36. *Mural*, 1943
Oil on canvas, 7 ft. 11¾ in. x 19 ft. 9½ in.
University of Iowa Museum of Art, Iowa City
Gift of Peggy Guggenheim

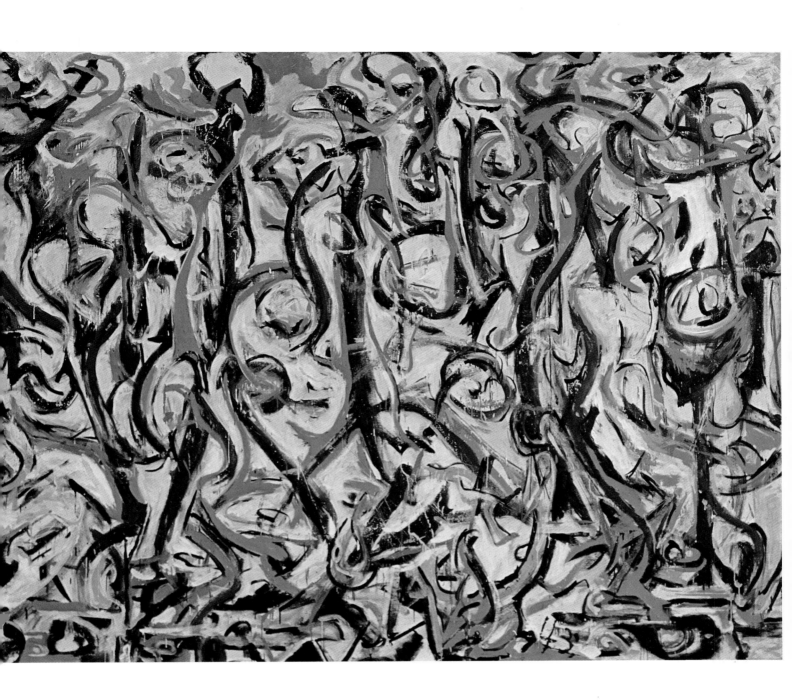

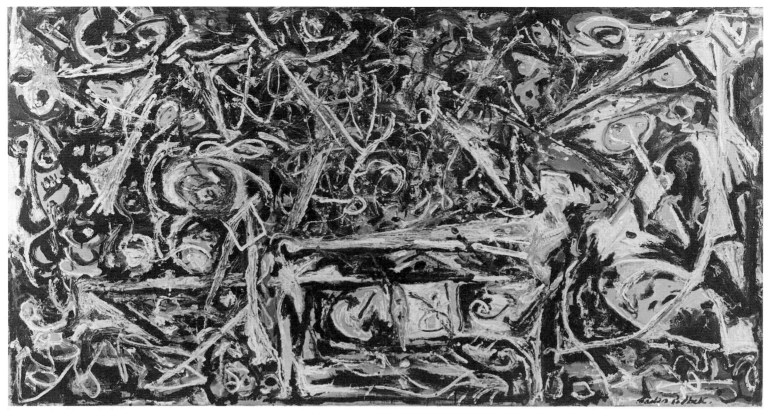

37

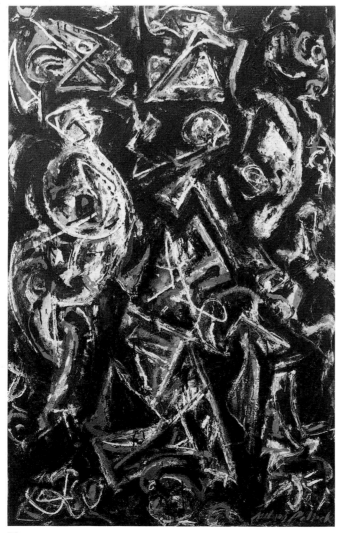

38

37. *Night Mist*, c. 1944
Oil on canvas, 36 x 74 in.
Norton Gallery and School of Art,
West Palm Beach, Florida

38. *Night Ceremony*, c. 1944
Oil and enamel on canvas, 72 x 43⅛ in.
Private collection

39. Drawing, c. 1939–42
Pen and black and brown ink, gouache, and
brushed ink on paper, 26 x 20½ in.
The Metropolitan Museum of Art, New York
Gift of Lee Krasner Pollock, 1982

40. Drawing, c. 1943
Black ink on paper, 10 x 13 in.
Lee Krasner Pollock

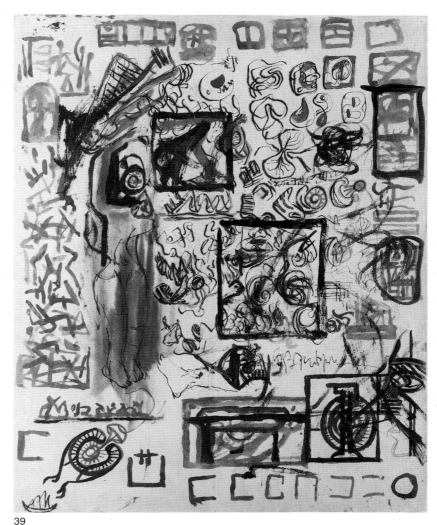

39

40

as allover line: *Totem Lesson 1* and *Totem Lesson 2*. Clement 42, 43
Greenberg singled them out in his review of the show as works
"for which I cannot find strong enough words of praise."[40] The
show, he continued, established Pollock "as the strongest painter of
his generation and perhaps the greatest one to appear since Miró.
The only optimism in his smoky turbulent painting comes from his
own manifest faith in the efficacy, for him personally, of art. There
has been a certain amount of self-deception in School of Paris art
since the exit of cubism. In Pollock there is absolutely none, and he
is not afraid to look ugly—all profoundly original art looks ugly at
first."[41]

The order of Pollock's art was not that of restraint and auster-
ity, but of amplitude and energy. The packed surface of *There* 45
Were Seven in Eight achieves an allover velocity that almost out-
races the painter's means. Pollock was out to ask of painting every-
thing that it could give.

The November 1943 show at Art of This Century and the sub-
sequent attention it brought thrust Pollock into a spotlight whose
glare would intensify over the next ten years. Pollock spoke pub-
licly about himself and his work for the first time in an interview in
the February 1944 issue of *Arts and Architecture*, in which he

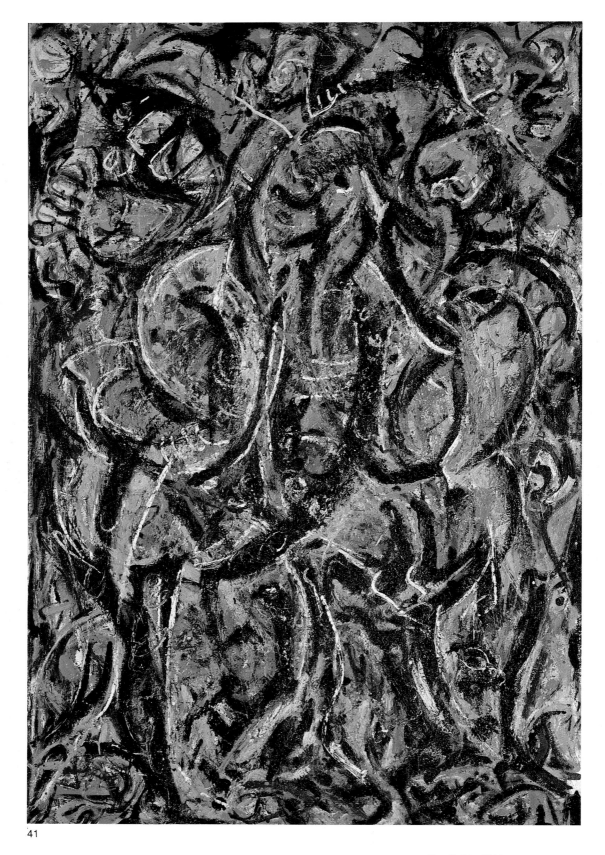

41

41. *Gothic*, 1944
Oil and enamel on canvas, 84⅝ x 56 in.
On extended loan to The Museum of Modern Art,
New York, from Lee Krasner

42. *Totem Lesson 1*, 1944
Oil on canvas, 70 x 44 in.
Mr. and Mrs. Harry W. Anderson Collection

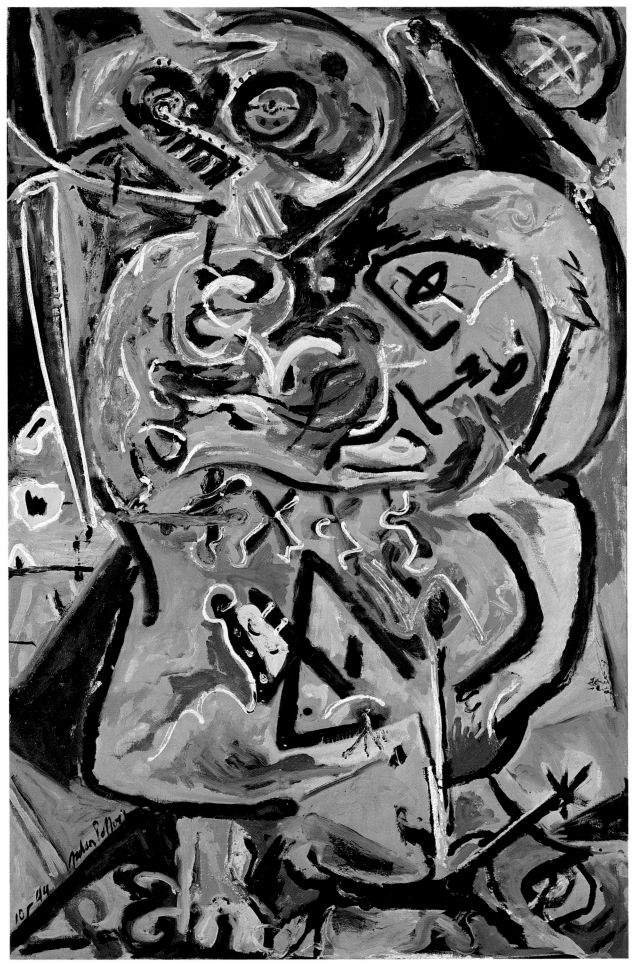

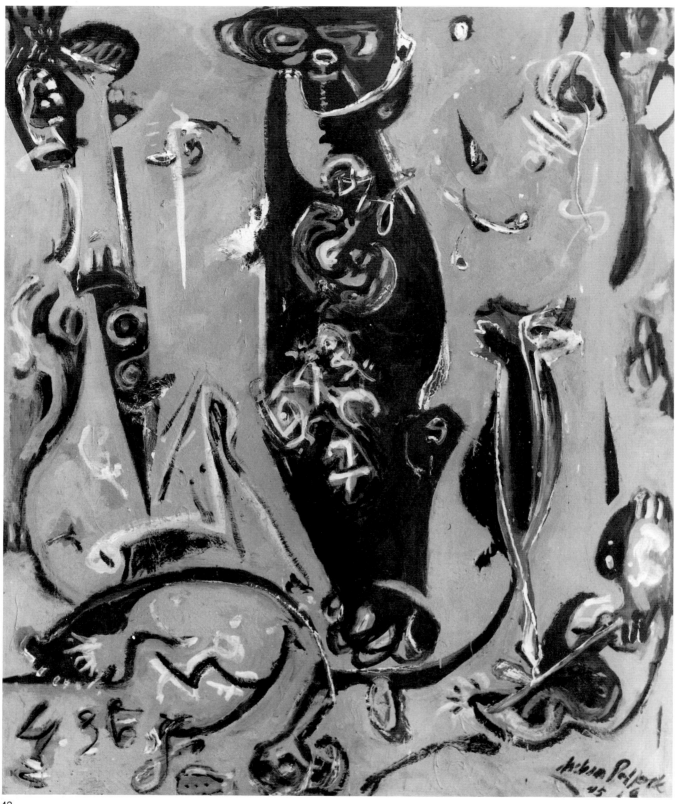

43

43. *Totem Lesson 2*, 1945
Oil on canvas, 72 x 60 in.
Lee Krasner Pollock

44. *Water Figure*, 1945
Oil on canvas, 71¾ x 29 in.
Hirshhorn Museum and Sculpture Garden,
Smithsonian Institution, Washington, D.C.

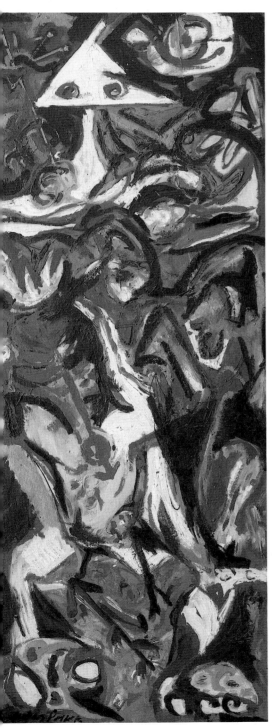

44

mentioned his feeling for the West and "the vast horizontality of the land" as well as his interest in American Indian art: "The Indians have the true painter's approach in their capacity to get hold of appropriate images, and in their understanding of what constitutes painterly subject-matter." But he cautioned against finding explicit references to American Indian art and calligraphy in parts of his pictures: "That wasn't intentional; probably was the result of early memories and enthusiasms."[42] When asked if he considered it important that there were many famous European artists currently living in America, he replied that he accepted the fact that the important painting of the last hundred years was done in France. American painters have generally missed the point of modern painting from beginning to end. (The only American master who interests me is Ryder.) Thus the fact that good European moderns are now here is very important, for they bring with them an understanding of the problems of modern painting. I am particularly impressed with their concept of the source of art being the unconscious. This idea interests me more than these specific painters do, for the two artists I admire most, Picasso and Miró, are still abroad.[43]

In the fall of 1945 Pollock and Krasner bought a farmhouse with about five acres of land and a large barn in Springs, Long Island. They were married in October and moved to Springs the following month. Living in Springs "allowed Jackson to work," Lee Krasner has said. "He needed the peace and quiet of country life."[44] He pushed ahead with new ideas, followed through on older ones. In *Water Figure* he disengaged, plane by plane and passage by passage, a totemic figure from its depicted presence, transforming it into a series of compacted abstract fragments. In other paintings, he experimented again with pouring, and reworked remnants of the blunt, angular forms he had used in his late 1930s paintings. For example, *Circumcision* has such densely packed vertical, horizontal, curving, and angled forms that there is a ceaseless combining and recombining of figural possibilities. The nearness of the ocean, the change of seasons, and the constant presence of the life of plants and insects reawakened Pollock's love of nature and led to some of his most lyrical work. The paintings in the Accabonac Creek series (named after a creek near the Springs property) open up and breathe. Forms unlock as contour and color separate and surfaces expand. *The Water Bull* is a broad field of loosely and vigorously drawn lines that only partially enclose patches of gesturally applied blues, greens, yellows, and reds. Large areas of canvas serve as both shape and color, while the whole movement toward fragmentation becomes a source of lyrical abstract rhythms. In *The Tea Cup* Pollock demonstrated that he could paint an elegant and very "French" painting, with high color and Cubist "fit" (as in the trim little grid enclosed by two vertical forms), and yet keep his touch exquisitely fluent and expressive. *The Blue Unconscious* also achieves a similar Cubist elegance even as separate shapes release their contours and appear to float into a proximately allover array.

Alloverness was implicit in this work; it remained for it to become explicit, and this happened in *Eyes in the Heat*, a thick, teeming impasto of brushwork and pigment laid on from the tube in

44

47

46

49

48

50

44

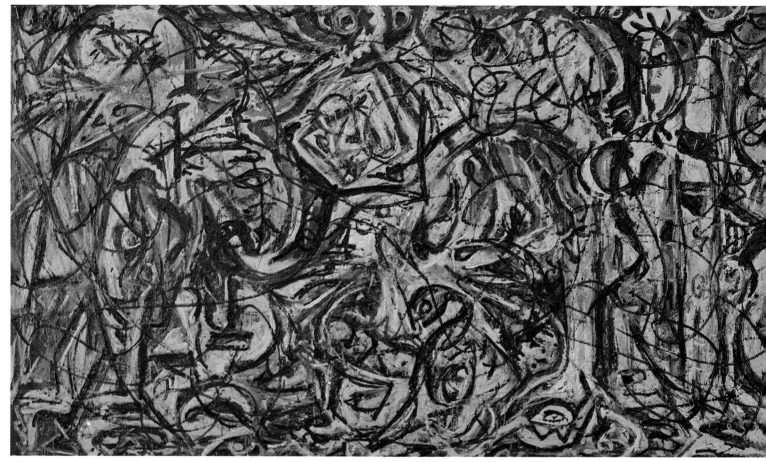

45

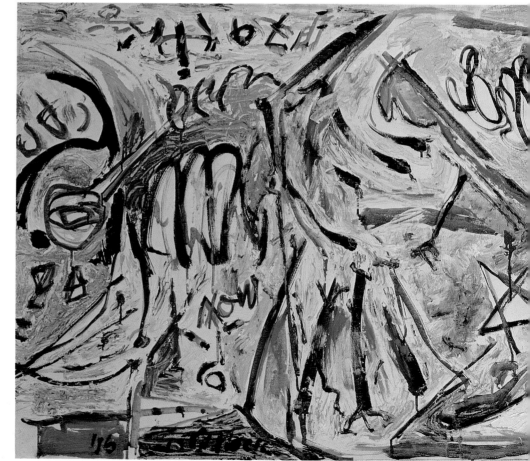

45. *There Were Seven in Eight*, c. 1945
Oil on canvas, 43 x 102 in.
The Museum of Modern Art, New York
The Mr. and Mrs. Walter Bareiss Fund
and Purchase

46. *The Water Bull*, c. 1946
Oil on canvas, 30⅛ x 83⅞ in.
Stedelijk Museum, Amsterdam

46

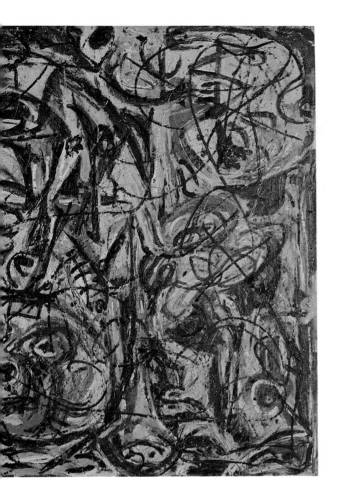

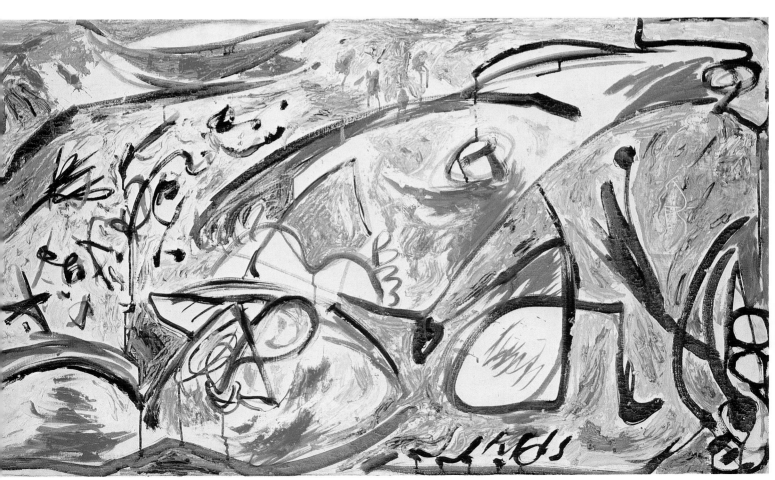

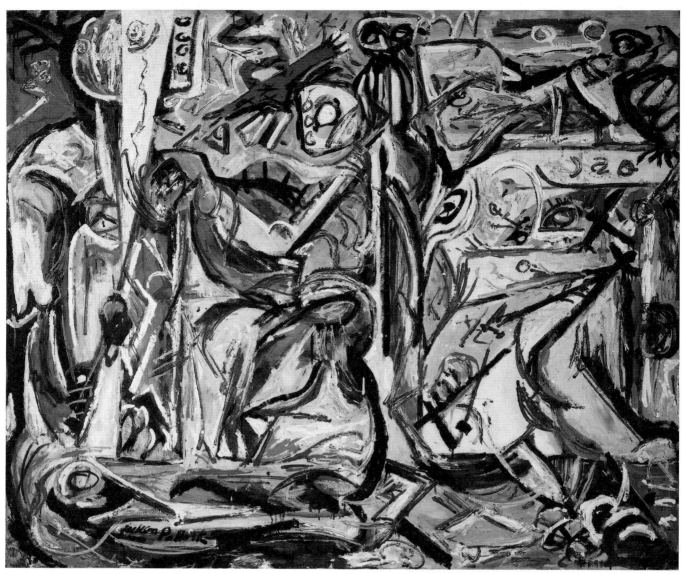

47

innumerable short, cursive strokes. Thinly painted ellipses—the "eyes" of the painting—stare through the surrounding encrustations, haunting Surrealist emblems of a visionary poetry. Hierarchical composition vanishes as the surface becomes a labyrinth of fissures and inscribings and ceaseless gesture. The painting, along with *Earth Worms* (1946) and *Shimmering Substance* (1946), was a crucial transitional work, in which Pollock, according to William Rubin, allowed his line to form "a series of looped and arabesqued patterns *all roughly similar in character and in approximate size* and *more or less even in density over the whole surface* of the picture."[45] This explicit alloverness, while seeming to dissolve the planarity of Cubist structure, actually subsumed the Cubist grid. It validated as well the Impressionist breakup and redistribution of the picture surface into innumerable molecular sites, each a node of "sensation." Pollock's explosive feeling and the logic of the main postulates of modernism thus achieved synonymy. Still, this

47. *Circumcision*, 1946
Oil on canvas, 56 x 66 in.
The Peggy Guggenheim Collection, Venice
The Solomon R. Guggenheim Museum, New York

48. *The Blue Unconscious*, 1946
Oil on canvas, 84 x 56 in.
Private collection

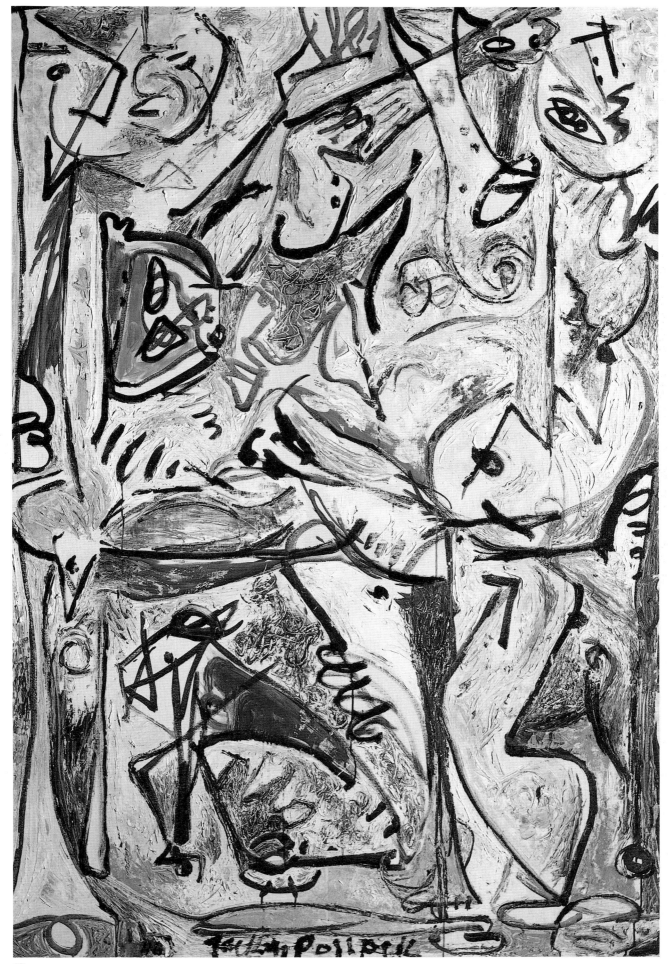

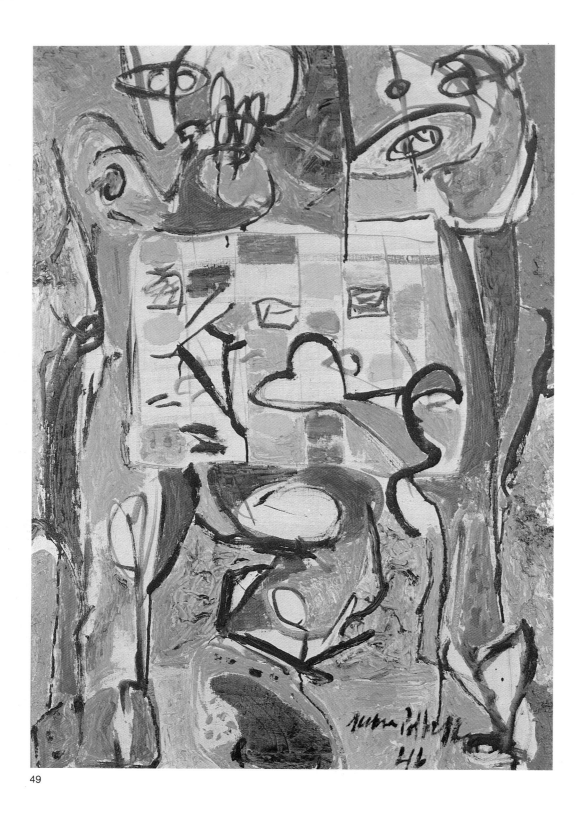

49

new and absolute alloverness was just the beginning. In order to solve the problem of achieving an alloverness divorced from the potentially "arty" connotations of traditional drawing—contouring, shaping, depicting—to find, in other words, an almost impersonal means to express an infinite flow of profoundly personal feeling, Pollock turned to pouring and to a form of picture-making where he was at once completely alone and completely himself.

49. *The Tea Cup*, 1946
Oil on canvas, 40 x 28 in.
Robert Elkon Gallery, New York

50. *Eyes in the Heat*, 1946
Oil on canvas, 54 x 43 in.
The Peggy Guggenheim Collection, Venice
The Solomon R. Guggenheim Collection,
New York

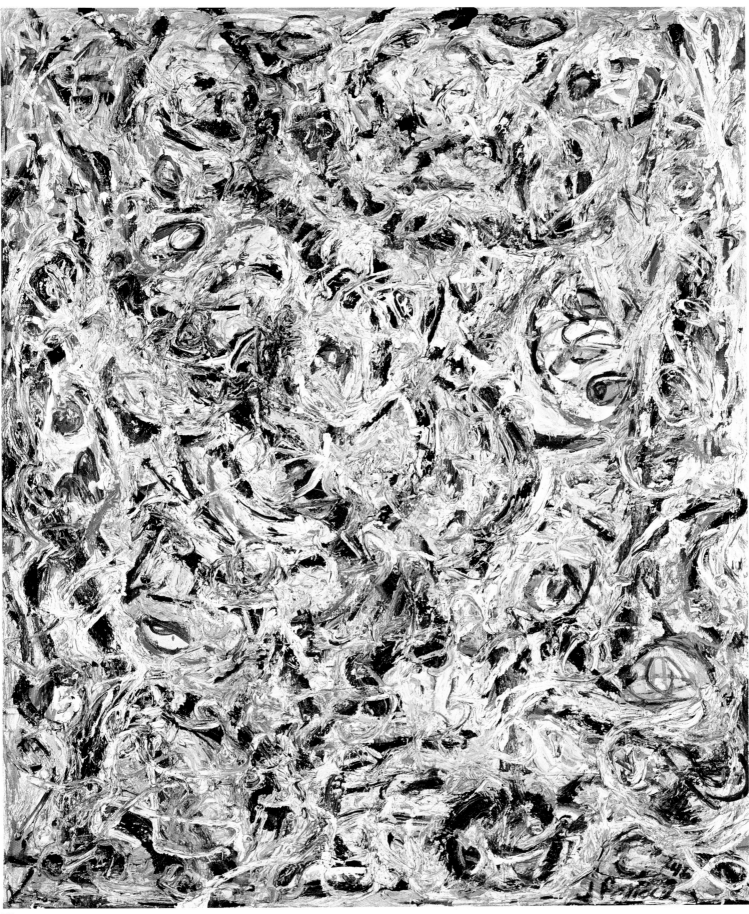

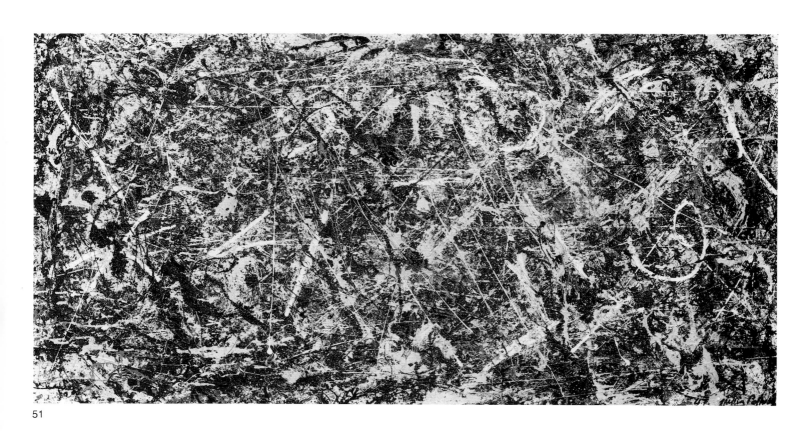

51

 # Springs, 1947–50

In the spring of 1946 Pollock had his third one-man show at Art of This Century, exhibiting paintings from both the Accabonac Creek series and the Sounds in the Grass series. Greenberg thought it his best show since the first, noting the presence of high, sharp color, but adding that "Pollock remains essentially a draftsman in black and white who must as a rule rely on these colors to maintain the consistency and power of surface of his pictures. As is the case with almost all post-cubist painting of any real originality, it is the tension inherent in the constructed, re-created flatness of the surface that produces the strength of his art."[46] He also observed that Pollock was moving in a direction beyond the framed easel picture toward the mural, and Pollock himself, applying for a Guggenheim Fellowship later that year, wrote:

I intend to paint large movable pictures which will function between the easel and the mural. . . . I believe the easel picture to be a dying form, and the tendency of modern feeling is towards the wall picture or mural. I believe the time is not yet ripe for a *full* transition from easel to mural. The pictures I contemplate painting would constitute a halfway state, and an attempt to point out the direction of the future, without arriving there completely.[47]

Over the next three years, Pollock made great art out of this "halfway state," preserving the tension between the easel picture, with its capacity to draw the viewer into a fictive world, and the mural, or wall picture, with its power to inhabit the viewer's own space. In retrospect, Pollock's 1942–46 work must be seen as profoundly preparatory to the unprecedented synthesis that now took place between Impressionism, Cubism, and Surrealist automatism[48] in his "poured" paintings of 1947–50. This synthesis ratified the logic of these movements, although ratification as such was not the primary intention any more than the application of new technique for its own sake was the primary intention. When Pollock began in late 1946 and early 1947 to drip and pour fluid enamel, aluminum, and oil paint from sticks and hardened brushes over pieces of sized, unprimed canvas tacked to the floor of his Springs studio, it was with a definite and urgent expressive end in mind. The practice of dripping and pouring paint was not a rabbit pulled out of a hat; Pollock had known about it for some time.

51. *Alchemy*, 1947
Oil on canvas, 45 x 87 in.
The Peggy Guggenheim Collection, Venice
The Solomon R. Guggenheim Museum, New York

52. *Full Fathom Five*, 1947. Overleaf
Oil on canvas, with nails, tacks, buttons, key, coins, cigarettes, matches, etc., 50⅞ x 30⅛ in.
The Museum of Modern Art, New York
Gift of Peggy Guggenheim

53. *Full Fathom Five*, detail. See page 65

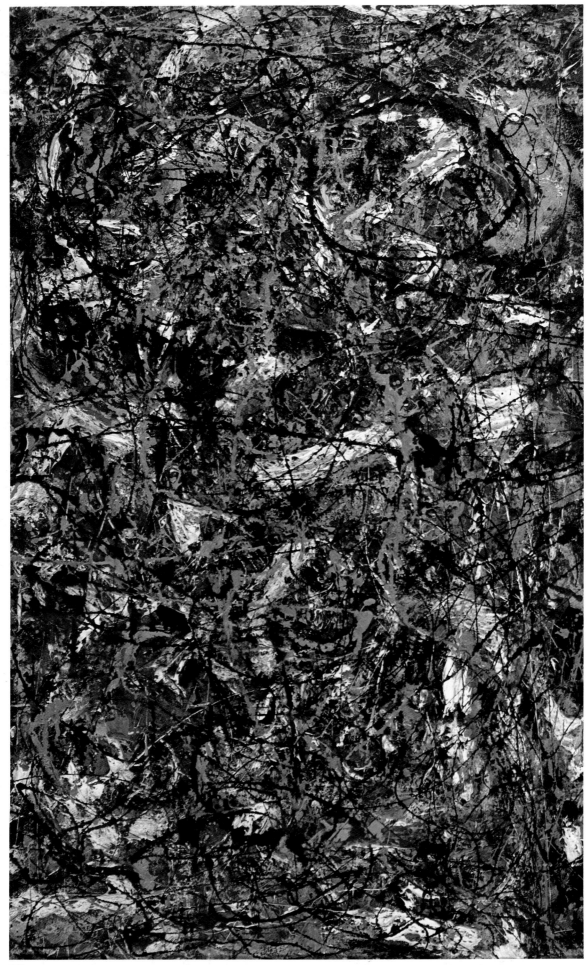

52

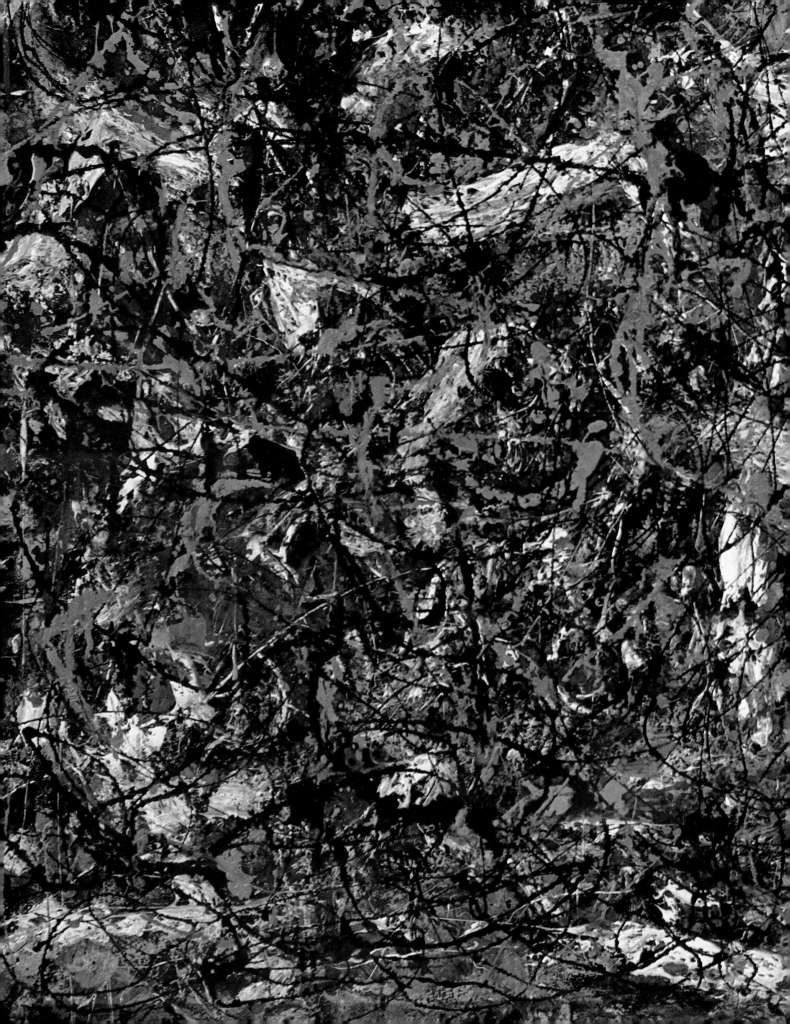

"The fact is that by the early forties," William Rubin writes, "the use of Duco and the practice of spilling it and letting it run on the surface was not at all uncommon as a marginal or 'coloristic' effect."[49] Pollock had seen it as early as 1936 in Siqueiros's Union Square workshop; Hans Hofmann had worked with it in the early 1940s, and Pollock had seen and admired, with Clement Greenberg, the allover paintings of Janet Sobel at Peggy Guggenheim's in 1944, which "showed schematic little drawings of faces almost lost in a dense tracery of thin black lines lying over and under a mottled field of predominantly warm and translucent color."[50]

Pollock, then, knew about pouring and had tried it before, but he waited until he had a problem that pouring alone could solve before he made it an integral part of his painting. That problem was centered in the inhibiting and retarding effects of brushwork, which even in so radical a painting as *Eyes in the Heat* was accompanied by inevitable associations with traditional hand and wrist inflections. These inflections, with their potential for preciosity, compromised the centrifugal rhythms of alloverness as well as the spontaneity alloverness was meant to convey. The stops and starts of loading, unloading, and reloading the brush further raised the specter of psychic censorship so inimical to the idea of automatist directness and authenticity. Pollock thus developed his "willful, actively directed drawing-with-paint"[51] to circumvent the habitual constraints of drawing as contour, and to encourage a greater contact with the unconscious. Alloverness achieved through pouring thus became a formal sign of the painting's access to unconscious sources, from which material emerged as the painting was brought increasingly into the realm of conscious aesthetic decision.

The pouring technique was phenomenally liberating. Pollock withdrew from the unconscious (or what he took to be the unconscious, which necessarily stored all that he had absorbed not simply from life but from his whole working history) an incredible range of feeling. Each painting is unique; Pollock never repeats himself or lapses into formula. His transforming powers, within single works, or from painting to painting, are uncanny, as earthy crusts become airy webs and dense, atomized clusters achieve a gauzy shimmer. The rhythmic repetitions of tossed paint meander, flow, bite, sear, and bleed, never turning into pattern or decoration, always renewing themselves with consummate freshness. Emotion, as in great poetry, undergoes change in the process of taking its own course. Turbulence becomes exaltation, violence becomes rhythm and measure, tenderness becomes exquisitely delicate lacework. Pollock stays with his feeling, following it, directing it, permitting it renewal through continual slight and subtle surprise. In one of the first of these canvases, *Full Fathom Five*, Pollock inserted nails, tacks, buttons, keys, combs, cigarettes, and matches—metaphors, in a sense, for the traditional drawing relentlessly swallowed by the arabesquing line that tears through the thick passages of white, green, orange, and magenta. His handprints are visible at the top and sides of *Number 1A, 1948*, signs of the artist's literal presence *in* his painting, as well as the painting's literal presence as a made and felt work of art that begins and ends in the use of materials. Then, in the icy etched lines of *Cathedral*,

52

56

55

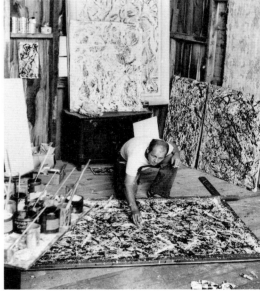

54

54. Pollock in his studio, 1947

55. *Cathedral*, 1947
Oil and aluminum paint on canvas, 71½ x 35¹⁄₁₆ in.
Dallas Museum of Fine Arts
Gift of Mr. and Mrs. Bernard J. Reis

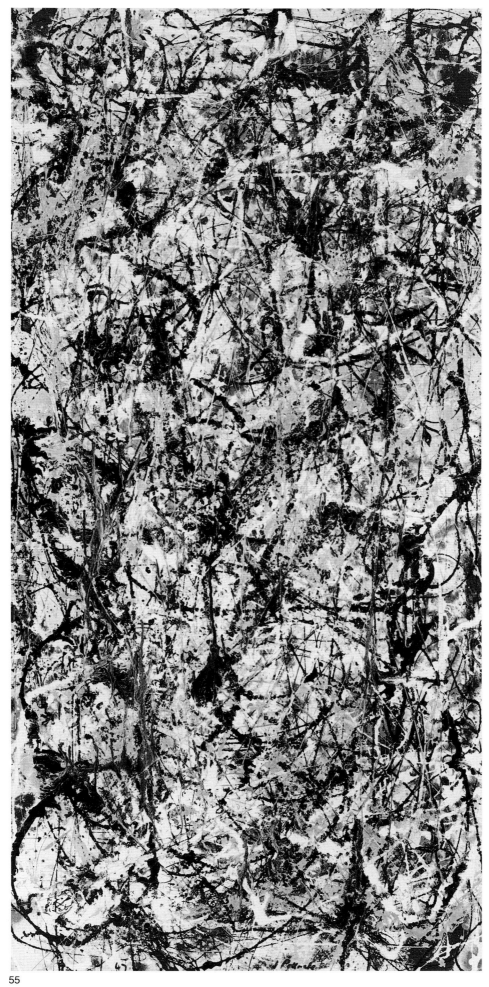

55

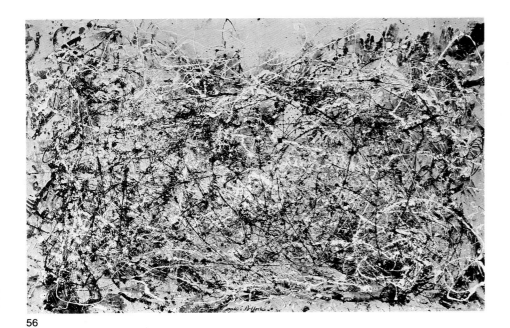

56

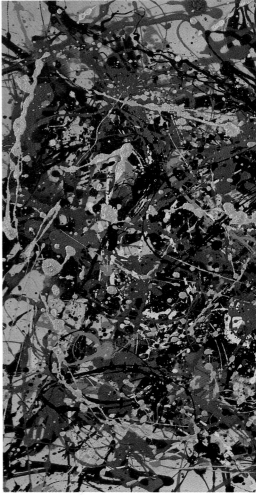

57

Pollock achieves a full statement of the sublime in a cool and distant transcendence of the material. He could do, in short, whatever he wanted to do in the great allover poured works. Pollock later said that he didn't use the accident, that, in fact, he *denied* the accident.[52] But he denied it by courting it, by assigning it a marginal but coherent role. As he wrote in the first and only issue of *Possibilities*:

When I am *in* my painting, I'm not aware of what I'm doing. It is only after a sort of "get acquainted" period that I see what I have been about. I have no fears about making changes, destroying the image, etc., because the painting has a life of its own. I try to let it come through. It is only when I lose contact with the painting that the result is a mess. Otherwise there is pure harmony, an easy give and take, and the painting comes out well.[53]

Pollock limited the field of each painting, conscious always of the framing edge as the point of demarcation between the picture and real space. Selvages kept at top and bottom edges, rhythmic lines that touch the edge and rebound into the painting are some of the ways he actively acknowledged the frame as the ultimate context for the painting. Within the tracery of the poured paint itself, Pollock achieved a style, in Michael Fried's characterization, in which "the different elements in the painting—most important, line and color—could be made, for the first time in Western painting, to function as wholly autonomous pictorial elements."[54] Its nature, Fried points out, was

optical, to distinguish it from the structured, essentially tactile pictorial field of previous modernist painting from Cubism to de Kooning and even Hans Hofmann. Pollock's field is optical because it addresses itself to eyesight alone. The materiality of his pigment is rendered sheerly visual, and the result is a new kind of space—if it still makes sense to call it space—in which conditions of seeing prevail rather than one in which objects exist, flat shapes are juxtaposed or physical events transpire.[55]

56. *Number 1A, 1948*, 1948
Oil on canvas, 68 x 104 in.
The Museum of Modern Art, New York
Purchase

57. *Number 8, 1949*, 1949
Oil, enamel, and aluminum paint on canvas,
34⅛ x 71¼ in.
Neuberger Museum, State University of New York
at Purchase
Gift of Roy R. Neuberger, 1971

58. Drawing, c. 1947
Brush, spatter, and pen and black and colored
inks on paper, 18¾ x 24⅞ in.
Private collection

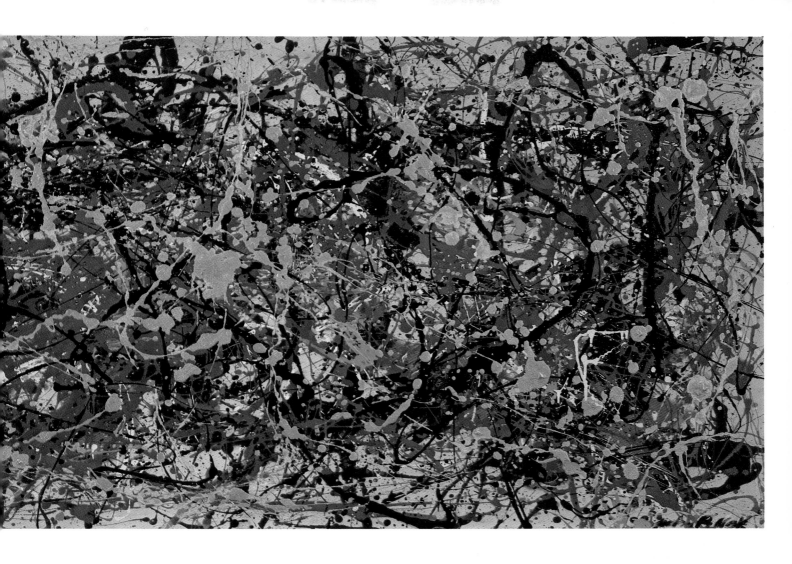

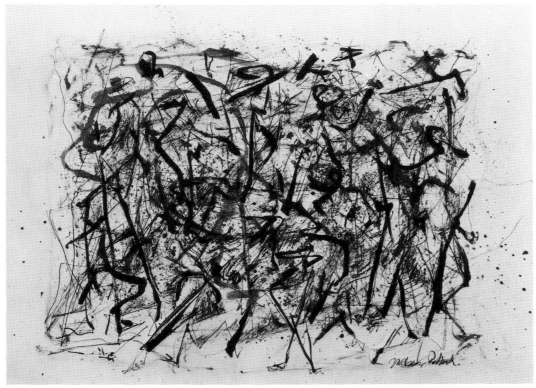

58

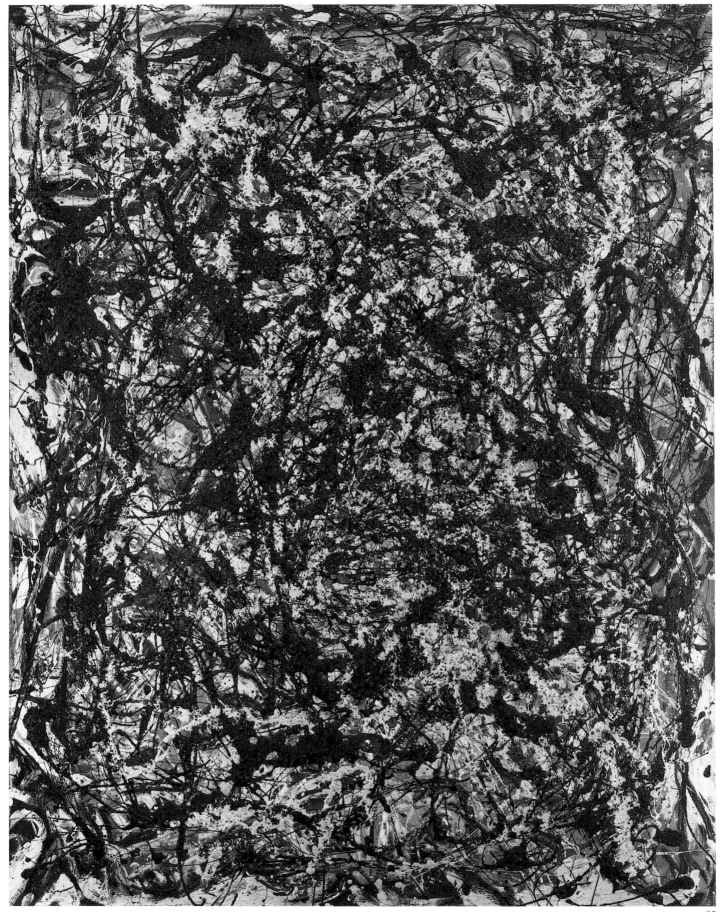

Eyesight, however, cannot be so easily divorced from the sense of touch, and tactility is not limited to the implication of three-dimensionality alone. Pollock's encrusted, puddled, labyrinthine, and weblike surfaces are physically, erotically present, and entice the viewer into a relation in which his body, and not just his eyesight, directly confronts the abstract field. This relation, which is at least as close to the experience of architecture as it is to the tradition of seeing through or "into" an illusionistic painting, can be deceptive. Sometimes the surface seems to hang as if in infinitely shallow relief in front of the canvas, as in *Number 1, 1949*, where the effect of "opticality" is strongest; sometimes it dissolves into immaterial radiance, as in the pinkish silvery luminescence of *Lavender Mist: Number 1, 1950*, another "optical" work. But there are paintings—*Number 1A, 1948* again comes to mind—where line, no matter how free from contouring, nevertheless has a sharp physical quality as it cuts with silken thinness through the pulverized skeins and webbings.

Pollock's line has a polymorphous potency—the capacity to be everywhere at once, to serve the ends of illusion and materiality. The poet Frank O'Hara put it as well as anyone ever has when he wrote: "There has never been enough said about Pollock's draftsmanship, that amazing ability to quicken a line by thinning it, to slow it by flooding, to elaborate that simplest of elements, the line—to change, to reinvigorate, to extend, to build up an embarrassment of riches in the mass of drawing alone."[56] It could no sooner be exclusively and reductively "optical" than it could be the slave of modernist literalness. It functioned supremely well as the vehicle of a speed-of-light alloverness, creating the impression that Pollock's great poured allover paintings arrived at their structure both internally and immediately (for all their dependence on a new process, these paintings do not, in fact, announce that process). Pollock's delicate crusts, which achieved an infinitesimal layer of relief, had profound affinities with two related modernist achievements, Analytic Cubism and the late wall-sized Monets. The relationship with Analytic Cubism, first discerned by Clement Greenberg, was subsequently affirmed by Pollock to both Greenberg and Tony Smith,[57] and has more recently been analyzed by William Rubin. As Greenberg first put it:

By means of his interlaced trickles and spatters, Pollock created an oscillation between an emphatic surface—and an illusion of indeterminate but somehow definitely shallow depth that reminds me of what Picasso and Braque arrived at . . . with the facet-planes of their Analytical Cubism. I do not think it exaggerated to say that Pollock's 1946–50 manner really took up Analytical Cubism from the point at which Picasso and Braque had left it when, in their collages of 1912 and 1913, they drew back from the utter abstractness to which Analytical Cubism seemed headed.[58]

A similar degree of utter abstractness had become implicit in the great late Monets, which, as William Rubin has pointed out, with their unprecedented largeness of scale and infinite molecularization of the surface into homogeneous atmospheres of light and dark, went as far as French painting had yet gone toward dissolving traditional references to objects and to the picture itself as a "win-

59. *Sea Change*, 1947
Collage of oil and small pebbles on canvas,
55⅞ x 44⅛ in.
The Seattle Art Museum, Washington
Gift of Peggy Guggenheim

72

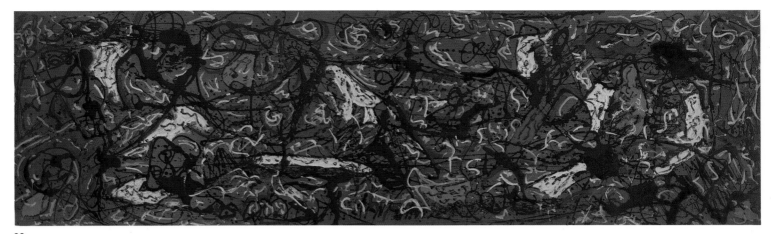

dow" into another world. Pollock's pictures were not directly influenced by these paintings, and yet his allover poured works, with their homogeneous distribution of light and dark "sensations" and their expanding, confrontational scale, *validated* the late Monet so profoundly that they initiated the awakening interest among painters in New York in the late 1940s to the nature and scale of Monet's achievement.

Still, the degree of Pollock's "utter abstractness" must remain a fascinating problem. Assuredly his allover pourings, purely as visual structures, are irrefutably, absolutely abstract. At the same time, having evolved from figuration, Pollock's line could resume it at any point, although to do so meant running the risk of losing its autonomous character. A number of poured paintings explore this problem: *Alchemy*, in which there are a number of mysterious inscriptions; *White Cockatoo: Number 24A, 1948*, which actually contains filled-in shapes (the one in the center in fact suggesting a cockatoo); *The Wooden Horse: Number 10A, 1948*, in which Pollock affixed a wooden hobbyhorse head to a drawn passage; and *Out of the Web: Number 7, 1949*, the most conceptually difficult of the three, where, inside one of the most tangled thickets of paint Pollock ever wove, he incised and removed pieces of painted canvas, creating figural shapes from the areas of underlying Masonite thus exposed. These biomorphic "absences," as the shapes might be called, imply the buried layers of figuration that compose the history of Pollock's abstraction, at the same time reversing the traditional relationship of ground and figure. Moreover these semifigural works cast the great allover pourings in a riddling light: at their most abstract, perhaps these paintings can be thought to possess what might be called a figurative *latency*, a potential for conversion and reconversion that is one major source of their seemingly unlimited energy.

Beyond the issues of figuration and abstraction, Pollock's 1947–50 paintings remain astonishing feats of pictorial invention. In the simple puddlings of a work on paper such as *Number 14, 1948: Gray*, he exercises perfect pictorial tact, sensing exactly how much black in relation to how much gray will achieve a dense but open

51
60
61
75

60. *White Cockatoo: Number 24A, 1948*, 1948
Enamel and oil on canvas, 35 in. x 9 ft. 6 in.
American Broadcasting Companies, Inc.

61. *The Wooden Horse: Number 10A, 1948*, 1948
Oil, enamel, and wooden hobbyhorse head on brown cotton canvas, mounted on board, 35½ x 75 in.
Nationalmuseum/Moderna Museet, Stockholm

62. *Number 13A, 1948: Arabesque*, 1948
Oil and enamel on canvas, 37¼ x 9 ft. 8½ in.
Richard Brown Baker Collection
Courtesy of the Yale University Art Gallery, New Haven, Connecticut

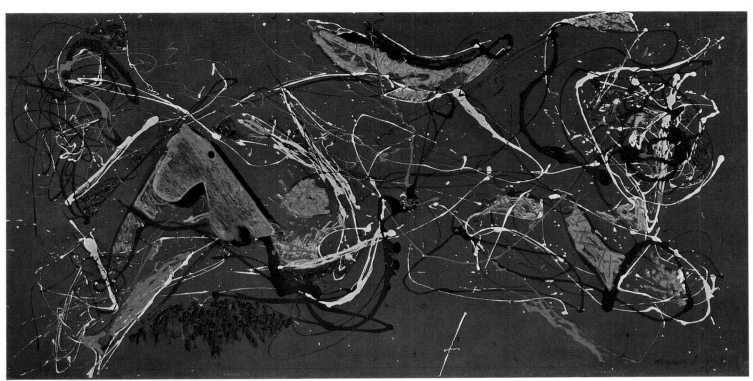

61

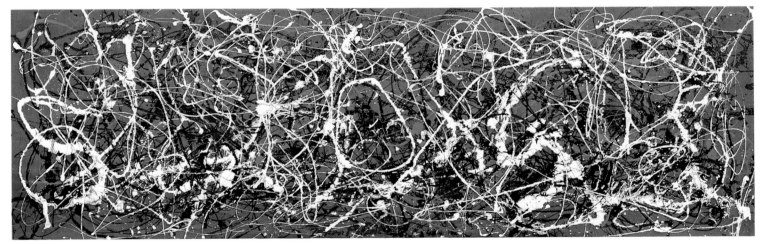

62

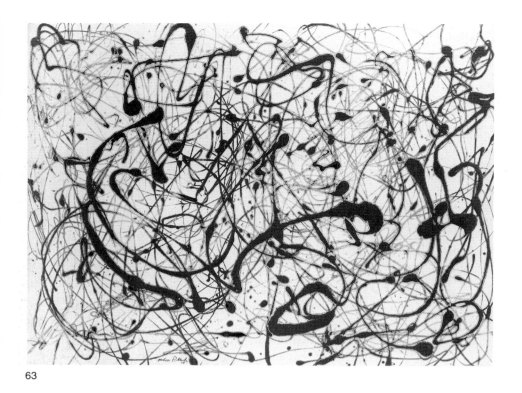

63

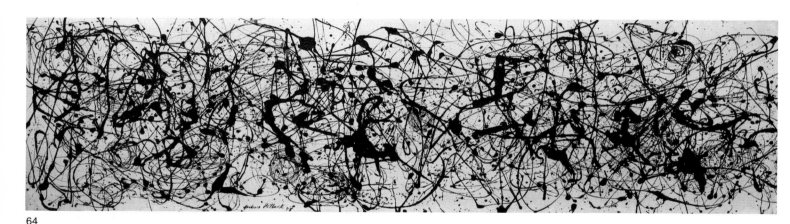

64

contrast of tones. He slows the movement of the eye across the
64 mural-scale expanse of *Number 7A, 1948* by abrupt about-facings
of blottings and poolings, forcing the painting's surface into dy-
65 namic oppositions. *Number 27, 1950* is opaque, expansive, and
cloudy, like pale, churning foam, whereas *Number 9, 1950*, with
its decisive interior framing, is a study in pictorial self-reference.
66 *Number 32, 1950* anticipates Pollock's later black paintings in its
contrast between the galvanic sprays of black paint and the stark
expanse of the white canvas.

Even in his earlier work Pollock only rarely emphasized color for
its own sake, and in the allover poured pictures it remains secon-
dary to the tonal abundance of black, white, and silver. Hues occur
throughout, but usually in extremely minute quantities, with the
effect that they tend to arrest the eye and to give local intensity to

65

63. *Number 14, 1948: Gray*, 1948
Enamel on gesso on paper, 22¾ x 31 in.
Yale University Art Gallery,
New Haven, Connecticut
The Katherine Ordway Collection

64. *Number 7A, 1948*, 1948
Oil and enamel on canvas, 36 in. x 11 ft. 3 in.
A. Alfred Taubman, Bloomfield Hills, Michigan

65. *Number 27, 1950*, 1950
Oil on canvas, 49 x 106 in.
Whitney Museum of American Art, New York

variations in the allover configuration, and to accent the intricate layering of flung and spilled paint. Color also works as a powerful emotional agent in Pollock's painting. The pinkish haze of *Lavender Mist* gives the painting its unearthly softness, and the spots of blue, pink, and silver in *One: Number 31, 1950* coalesce in another haze of light and dark. In *Autumn Rhythm: Number 30, 1950*, one of Pollock's most elegiac paintings, brief, very spare driblets of blue temper the commanding large presences of black, white, and tan, counterpointing their somberness and accenting the painting's intensely private, yet exalted feeling.

By the time Pollock painted *Lavender Mist* and *Autumn Rhythm*, he had become a famous, even a notorious man. He had been discussed in *Life* magazine, not once, but twice, in "A *Life* Round Table on Modern Art," in October 1948, and again in the August 8, 1949, issue, in an article called "Jackson Pollock: Is He the Greatest Living Painter in the United States?" The magazine, which apparently needed to ridicule what it could not understand, described his pouring method as *drooling*. In 1950 the *New Yorker* carried an interview with Pollock and Lee Krasner in "The Talk of the Town" section in which they explained why he gave his pictures numbered titles: "Numbers are neutral. They make people look at a picture for what it is—pure painting," Krasner said, and Pollock added, "I decided to stop adding to the confusion. . . . Abstract painting is abstract. It confronts you."[59]

For the most part Pollock ignored his unsympathetic and uninformed critics, with one exception. *Time* magazine, which was even more dedicated than *Life* to insinuating that Pollock and his generation were a pack of frauds, carried an article in the November 20, 1950, issue called "Chaos, Damn It!" in which Italian critic

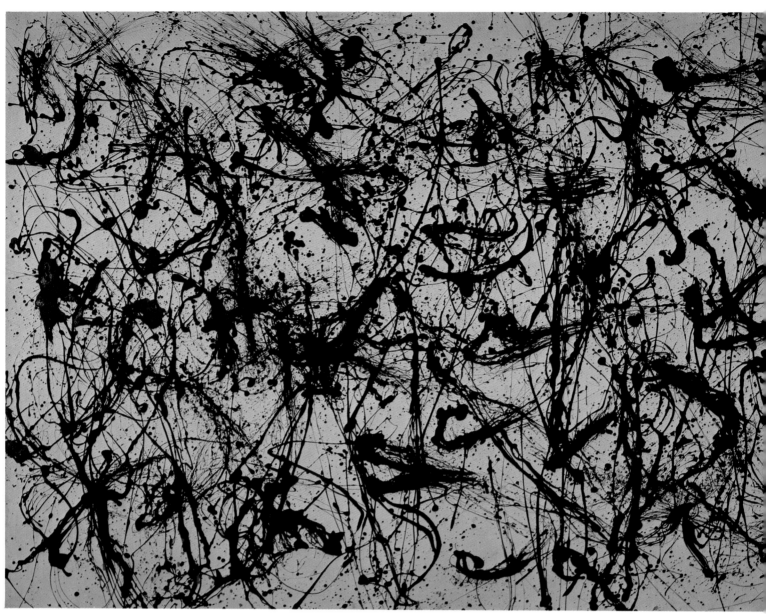

66

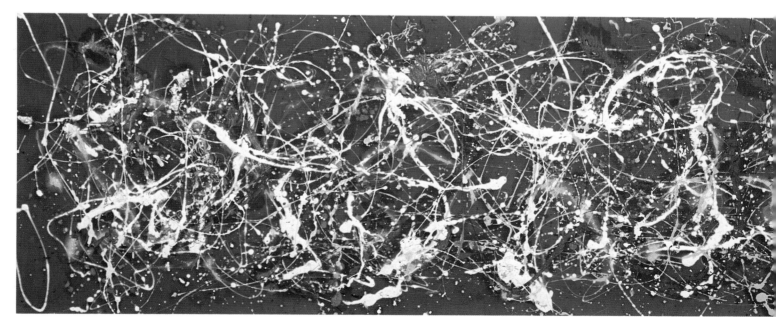

67

68

66. *Number 32, 1950*, 1950
Enamel on canvas, 8 ft. 10 in. x 15 ft.
Kunstsammlung Nordrhein-Westfalen, Düsseldorf

67. *Number 2, 1949*, 1949
Oil on unsized canvas, 38⅛ in. x 15 ft. 9½ in.
Munson-Williams-Proctor Institute, Utica,
New York

68. *Number 13, 1949*, 1949
Oil, enamel, and aluminum paint on gesso ground
on paper, mounted on composition board,
22¾ x 30⅞ in.
Leonard Yaseen—Steven Easton

69

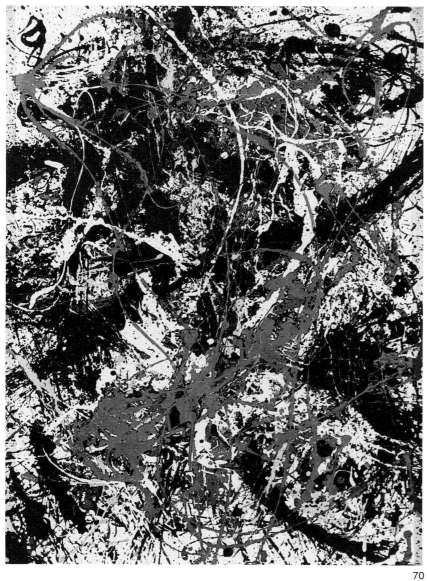

70

69. Drawing, c. 1950
Enamel on paper, 11⅛ x 59¹⁄₁₆ in.
Graphische Sammlung, Staatsgalerie Stuttgart

70. *Number 15, 1949*, 1949
Enamel and aluminum paint on gesso ground
on paper, mounted on composition board,
31 x 22⅜ in.
Private collection

71. Jackson Pollock in his studio
Photograph by Hans Namuth

Bruno Alfieri was quoted as describing Pollock's work as unmeaning "chaos."[60] Pollock quickly fired off a telegram, which was published in the December 11 issue: "NO CHAOS DAMN IT. DAMNED BUSY PAINTING AS YOU CAN SEE BY MY SHOW COMING UP NOV. 28. I'VE NEVER BEEN TO EUROPE. THINK YOU LEFT OUT MOST EXCITING PART OF MR. ALFIERI'S PIECE."[61] [This was a comparison between Pollock and Picasso that favored Pollock.]

Perhaps to set the record straight—to demonstrate that his working methods were just the opposite of chaos—Pollock agreed to be the subject of a short film produced by Paul Falkenberg and photographer Hans Namuth. The film was shot mostly outdoors in several sessions during September and October 1950, and Pollock himself supplied a direct and simple narration for it, for the most part compiled from previous statements.

The film is an invaluable document. The first sequence shows Pollock in his studio moving around the four sides of a canvas on the floor. The movements are graceful, beautiful even, but they are not, as they have often been called, a dance: they are untrancelike, unrehearsed, unroutinized. What the swift eye-to-hand movements do reveal is a sense of immediate, intuitive decision. Spontaneity and directness, of course, do enter into Pollock's process: they are intentional, products of the decision making itself, as we see in the second sequence of the film, which shows him starting a painting on glass, rubbing it out, and starting again after saying, "I lost contact with my first painting on glass, and I started another one."

The Namuth-Falkenberg film was shown at the Museum of Modern Art on June 14, 1951, and was quickly followed up by Namuth's publishing, in the magazine *Portfolio*, a series of photographs he had taken of Pollock over the summer of 1950. Some of these photos were included in Robert Goodnough's *Artnews* article, "Pollock Paints a Picture," also published in 1951. The act of painting is only one part of what it means to make a painting. Hours of rumination, of working through problems and revising

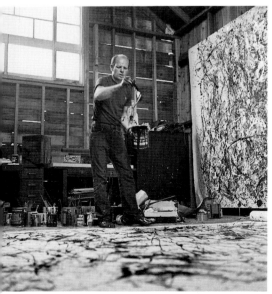

71

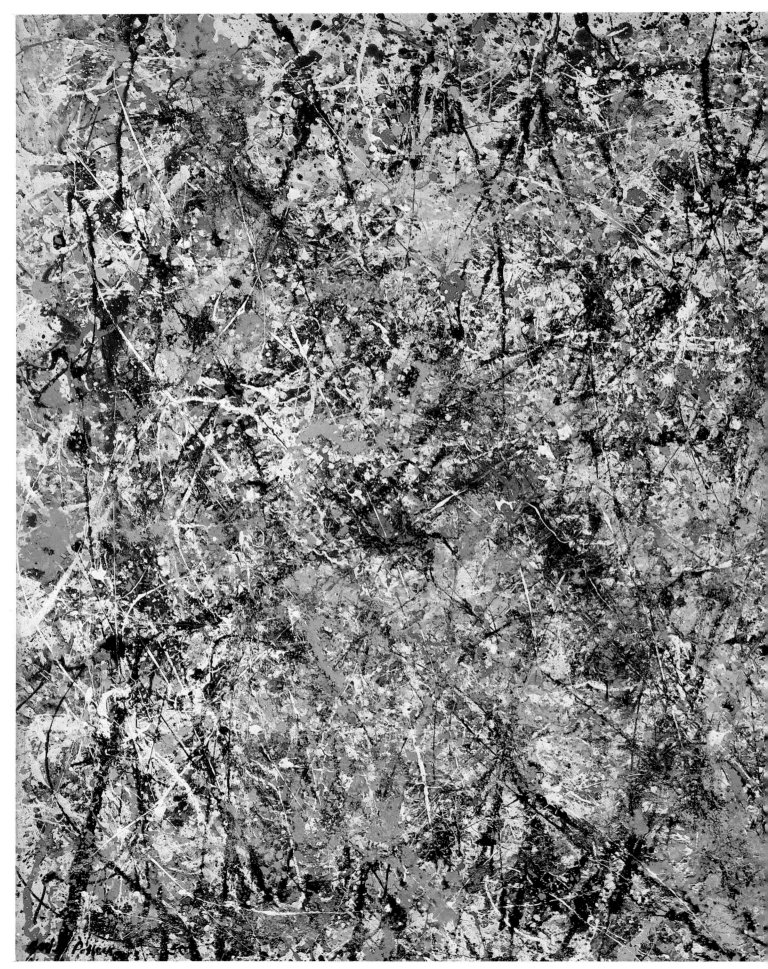

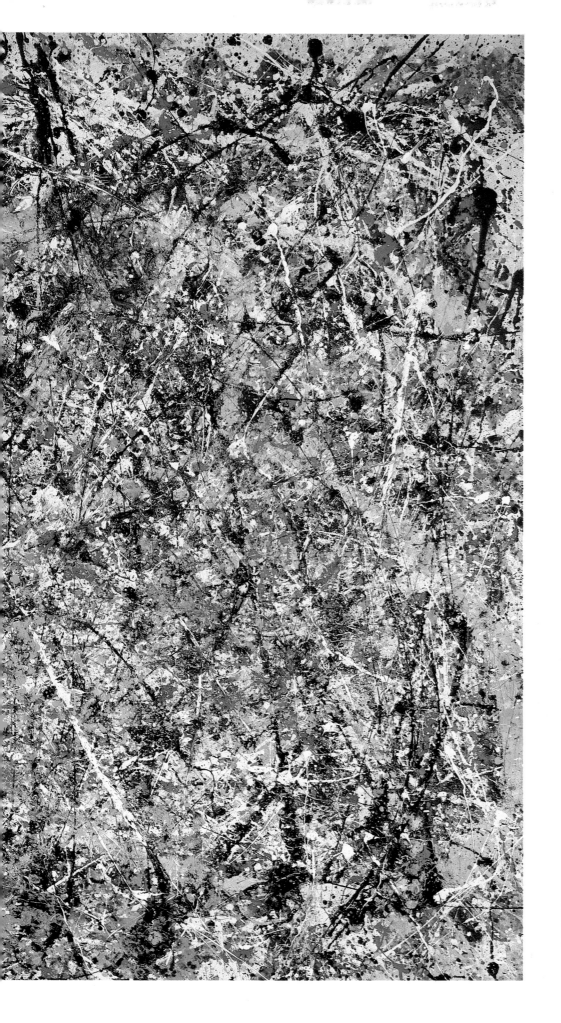

72. *Lavender Mist: Number 1, 1950*, 1950
Oil, enamel, and aluminum paint on canvas,
87 in. x 9 ft. 10 in.
National Gallery of Art, Washington, D.C.
Ailsa Mellon Bruce Fund

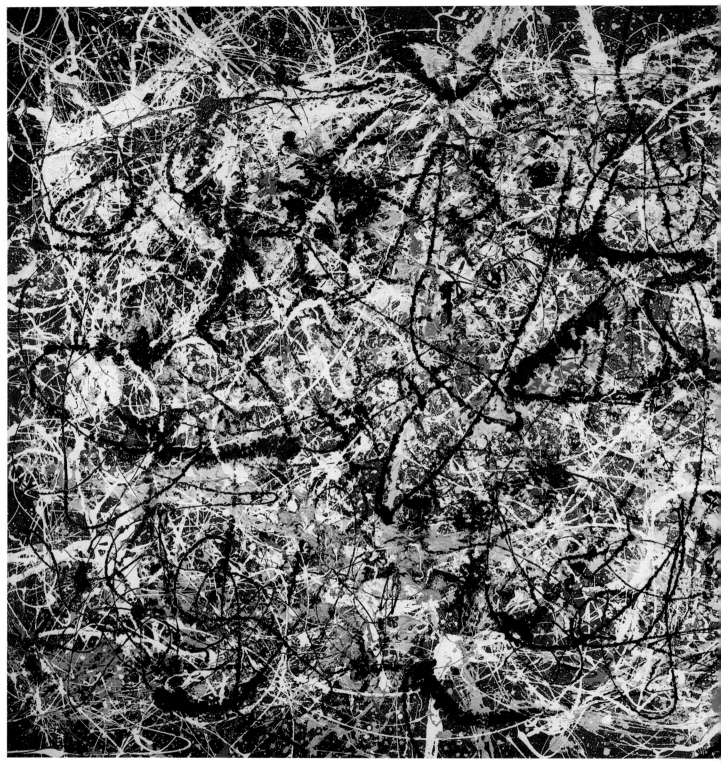

73

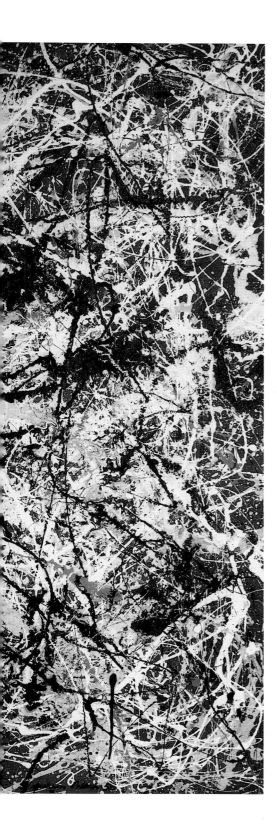

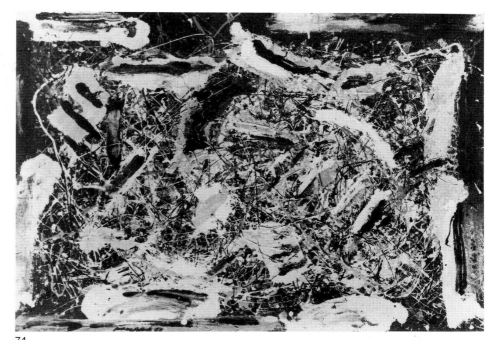

74

73. (*Mural*), 1950
Oil, enamel, and aluminum paint on canvas,
mounted on wood, 72 x 96 in.
Tehran Museum of Contemporary Art

74. *Number 9, 1950*, 1950
Enamel on brown cotton duck, 36 x 52 in.
Private collection

decisions go into painting, hours of simply sitting and looking at the canvas before or after the physical application of paint. Yet the film and the photographs soon gave rise to a new interpretation of Pollock's achievement, one that shifted the emphasis from the art to the artist, and tended to ignore the role of decision and thinking in his working process. According to Barbara Rose, "The focus on the *act*—the process of art making—instead of on the static object changed the course of art criticism and even art history in a way Namuth himself could never have foreseen or intended."[62] Pollock became a hero of inarticulate spontaneity, a man who painted his autobiography, who broke down the barriers between art and life. That he once said, "I do have a general notion of what I'm about and what the results will be"[63] went unheard in the din of existentialist romanticism that now harried him.[64] Two years after the film was made, in December 1952, Harold Rosenberg put the stamp of official art history upon this view when he announced in "The American Action Painters" that:

At a certain moment the canvas began to appear to one American painter after another as an arena in which to act—rather than as a space in which to reproduce, re-design, analyze or "express" an object, actual or imagined. What was to go on the canvas was not a picture but an event.

The painter no longer approached his easel with an image in his mind; he went up to it with material in his hand to do something to that other piece of material in front of him. The image would be the result of this encounter.[65]

It was not until ten years later, in 1962, in an article in *Encounter* called "How Art Writing Earns Its Bad Name," that Clement Greenberg attempted to correct this implicit travesty of Pollock's work by pointing out that his paintings were autonomous works of art that should be judged by their aesthetic failure or success. By

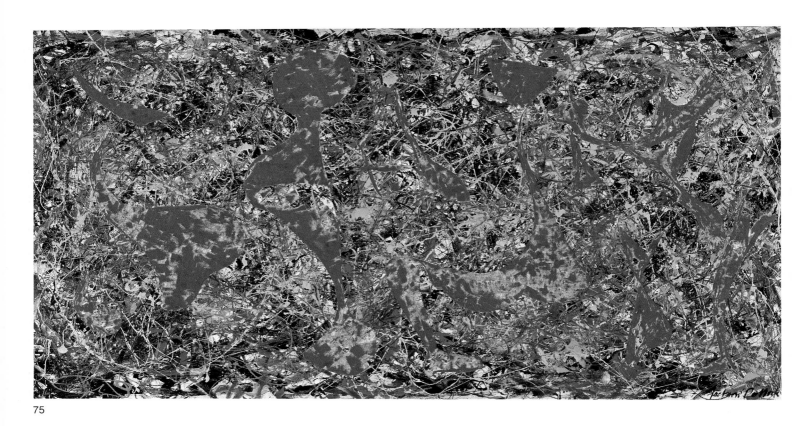

75

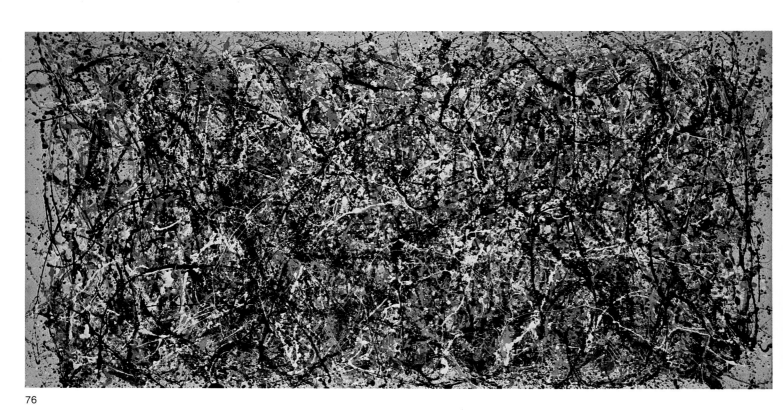

76

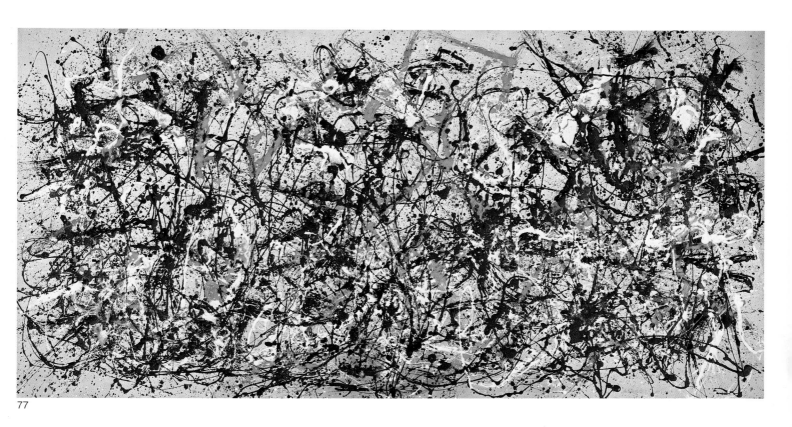

77

75. *Out of the Web: Number 7, 1949*, 1949
Oil and enamel on Masonite, cut out, 48 x 96 in.
Staatsgalerie Stuttgart

76. *One: Number 31, 1950*, 1950
Oil and enamel on canvas,
8 ft. 9⅞ in. x 17 ft. 5½ in.
The Museum of Modern Art, New York
Gift of Sidney Janis

77. *Autumn Rhythm: Number 30, 1950*, 1950
Oil on canvas, 8 ft. 10½ in. x 17 ft. 8 in.
The Metropolitan Museum of Art, New York
George A. Hearn Fund, 1957

that time the notion of "Action Painting" had become entrenched in American culture, spawning a variety of developments, including Allan Kaprow's "Happenings." Kaprow later wrote that "The expanding scale of Pollock's works, their iterative configurations prompting the marvelous thought that they could go on forever in any direction including out, soon made the gallery as useless as the canvas, and choices of wider and wider fields of environmental reference followed. In the process, the Happening was developed."[66]

Pollock's brooding appearance in the Namuth photos, his cowboy boots and denim, and the ever-present cigarette dangling from his lips or held nonchalantly between his fingers no doubt helped to deflect attention away from his paintings and onto himself, ultimately feeding a popular view of the artist as an inspired existentialist savage. This myth has dominated the generally received idea of Pollock ever since, and has given rise to such recent pieces of nonsense as that for Pollock, "The act of painting was like a religious ritual which held him in a continual state of lucid delirium."[67] This myth, then, is still with us, and we are still trying to catch up with all its distortions and omissions.

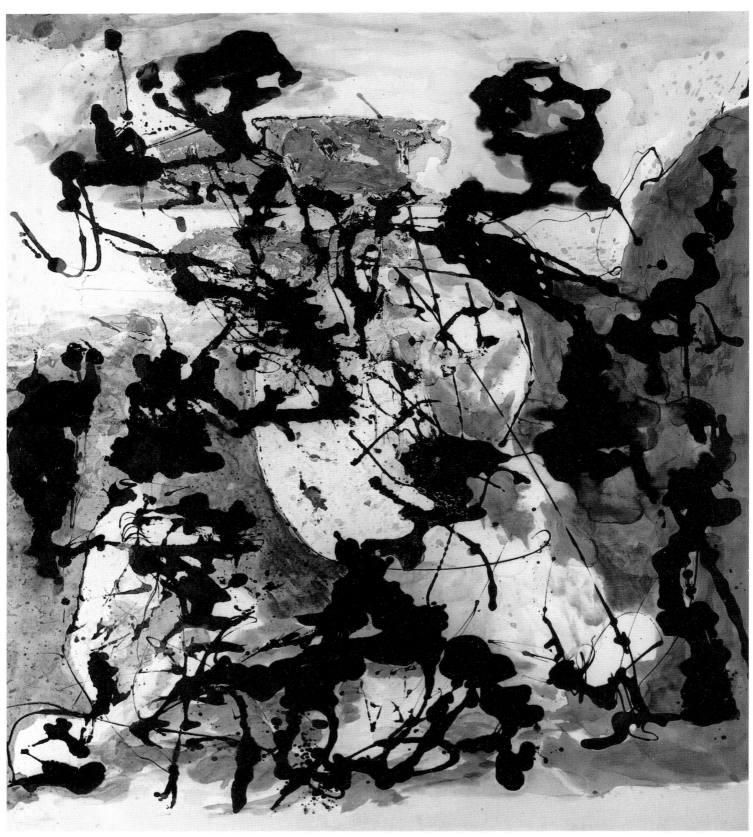

78

 The Black Paintings, 1950–53

In June 1952 Pollock wrote to his friend the painter Alfonso Ossorio: "Ive had a period of drawing on canvas in black—with some of my early images coming thru—think the non-objectivists will find them disturbing—and the kids who think it simple to splash a Pollock out."[68] His prediction was right. When these paintings were showed at Betty Parsons the following November, they profoundly unsettled those who saw them. The return of figuration baffled Pollock's critics, and continues to do so. Clement Greenberg later saw the black paintings as the product of Pollock's turning "to the other extreme, as if in violent repentance" over his 1947–50 breakthrough, and as a retraction of "almost everything he had said in the three previous years."[69] Michael Fried separated the black paintings into those that, in their proto-staining technique, anticipated the works of Morris Louis and other color-field painters, and those that, through their return to "something close to traditional drawing . . . probably mark Pollock's decline as a major artist."[70]

There is no question that the black paintings are difficult, problematic, and at times aesthetically unsuccessful. They represent a marked change, but is it as discontinuous and regressive a change as at first appears to eyes that see the allover poured paintings as the summit of Pollock's most "advanced" work? It is important to bear in mind that Pollock always tended to test himself, to interrogate what he had done, and in this respect his ongoing self-criticism fulfilled modernism's demand that a serious artist continually question his medium, its traditions and conventions, and the grounds of his own achievement. His development in general, as critics have noticed, had always been dialectical, oscillating between the poles of abstraction and figuration. Thus it makes sense to ask whether, and how, the black paintings participate in this process and to explore the possibility that they represent a dialectical swing from drawing-as-painting to painting-as-drawing.

This is not to deny an important role to psychological content which, as Greenberg implies, might have been bound up with no less a force than guilt caused by Pollock's successful competition with his precursors. Francis V. O'Connor, in his monograph on the black paintings, points out that for Pollock to work exclusively

78. *Number 12, 1952*, 1952
Oil on canvas, 101¾ x 89 in.
Formerly Nelson A. Rockefeller Collection;
destroyed by fire

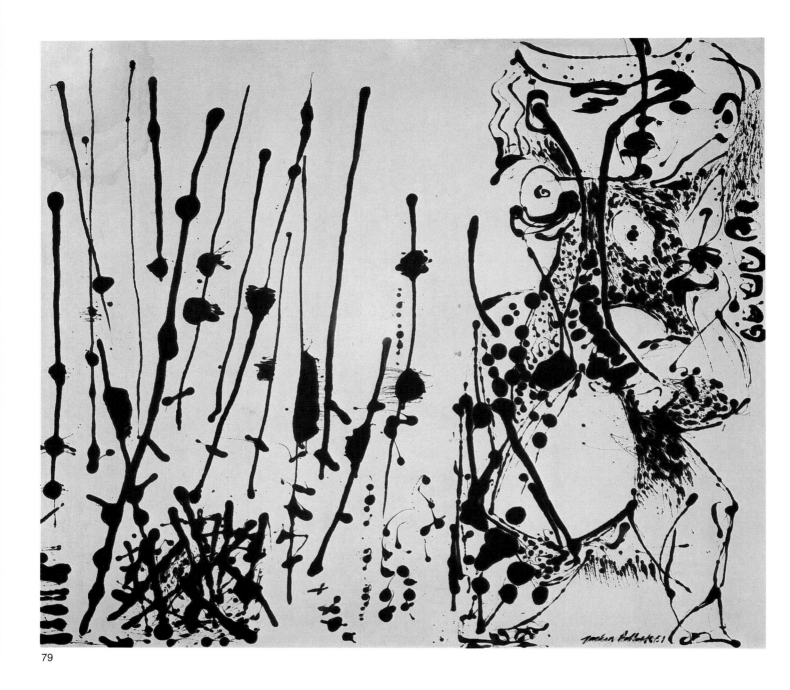

79

in black was "to make a symbolic choice,"[71] and he further pro-
poses that black, for Pollock, was the archetypal color of mourn-
ing.

What, in addition to his success (i.e., his "beating out" of his
rivals), did Pollock have to mourn? For one thing, his lost sobriety,
which may have been a result of the first problem. For two years,
1948–50, he had not touched alcohol. Then, in October 1950, at
the end of a cold day of filming with Namuth, Pollock took his
first drink in over two years, with the catastrophic result that he
resumed heavy and often uncontrollable drinking. But putting aside
drinking and hypothetical guilt for a moment (he had drunk heav-
ily before 1947 and made great paintings, and had presumably
coped with "success anxiety" before as well), Pollock's sensing a

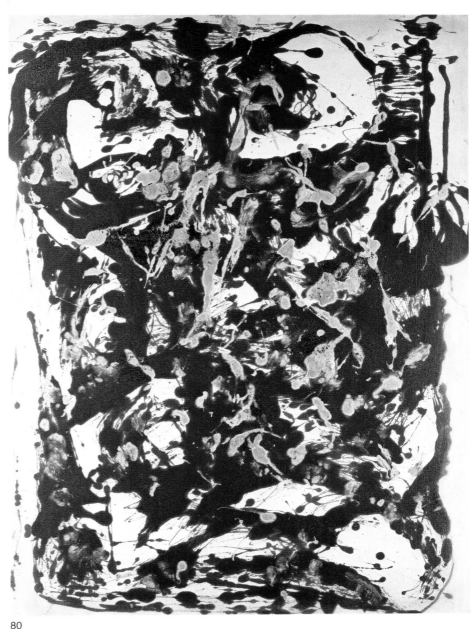

80

79. *Number 7, 1951*, 1951
Enamel on canvas, 56 x 65 in.
Private collection

80. (*Brown and Silver I*), c. 1951
Enamel and silver paint on unprimed canvas,
57 x 42½ in.
Thyssen-Bornemisza Collection,
Lugano, Switzerland

need for aesthetic change emerges as the most salient of the motives for the black paintings. As Lee Krasner has said, "After the '50 show, what do you do next? He couldn't have gone further doing the same thing."[72] Pollock's gift was primarily linear, and black, virtually from the beginning of his working life, had signified line. Black, then, presented a search for renewal and change from within the most recent as well as the oldest, most essential elements of his art.

Technically speaking, the black paintings are not radically discontinuous with Pollock's 1947–50 working methods. He still poured paint from the can, from sticks and hardened brushes, and to these implements he now added basting syringes. He still worked from all four sides of the canvas, postponing decisions about what

was to count as the bottom or top until the painting was finished or close to finished. What was different was that he did not tack down a single piece of cotton duck to the floor, but often unrolled large bolts of canvas. Sometimes he would cut a piece from the roll before painting; sometimes he would finish a painting and then cut it from the roll; sometimes, when working with smaller paintings, he would do a number of paintings on a large strip, which he would then cut and study.[73] He would size the canvas (sometimes after he had made the painting), but did not prime it, with the result that the black and sometimes brown industrial enamels he used often seem to have stained the canvas.

It was in the paintings' imagery that there is violent discontinuity with the work of 1947–50. Krasner, we remember, had once asked Pollock why, in his abstract paintings, he did not stop painting once he had arrived at a given image, and he had replied, "I choose to veil the imagery." "With the black-and-whites," she has said, "he chose mostly to expose the imagery."[74] This imagery, she also points out, evolved from Pollock's early drawings and sketchbooks: "all of Jackson's work grows from this period [1934–35 on to 1941–42]; I see no more sharp breaks, but rather a continuous development of the same themes and obsessions."[75] Figures return, sometimes buried in an allover composition, sometimes in a modified alloverness that harks back to his proto-allover drawings in which he distributed semiautonomous or autonomous shapes across a page. The imagery revived earlier structural concerns as well. The two-part structure of *Number 7, 1951* recalls, as O'Connor has claimed, the very early (*Landscape with Rider I*) (1933), while the full-length figure of the woman brings to mind the female figure in (*Woman*) (1930–33) as well as Pollock's Picassoid drawings of the late 1930s and early '40s. The thin "poles" on the left are still another resurgent motif, and in juxtaposition with the female figure suggest the return of Pollock's interest in bipolar, or male-female, imagery.

Just how specific Pollock's new images are, and therefore the extent to which they constitute a return to traditional drawing, remains extremely problematic. Michael Fried argues that Pollock's line in the classic poured paintings is radical in its break with the traditional function of *contouring*—contouring serving traditionally as the sign, in drawing, of closed form and hence of *volume*. But Lawrence Alloway disagrees with Fried on just this point, claiming that, "as a rule, Pollock's iconography" in the black paintings "is not conveyed by volume-inducing lines. The lines not only have a non-directional property, as they stain out onto the canvas, but the sign-system in use is not one based on the perception of solids and their translation into a two-dimensional system."[76] Since Pollock's images were not rendered as observed entities, but as spontaneous, automatist upwellings from the inner pool of Freudian-Jungian-Surrealist-oneiric-mythopoeic images, his line, Alloway concludes, was necessarily ideographic and calligraphic.

But just as line in the classic pourings reserves at all times its figurative latency, the blottings, stainings, and poolings of the black paintings, which are insistently material and abstract, move

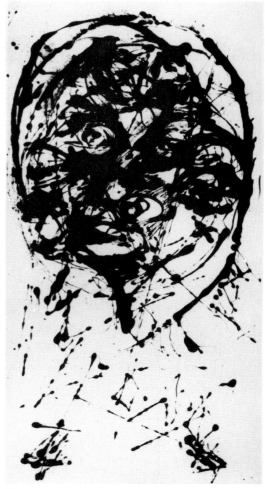

81

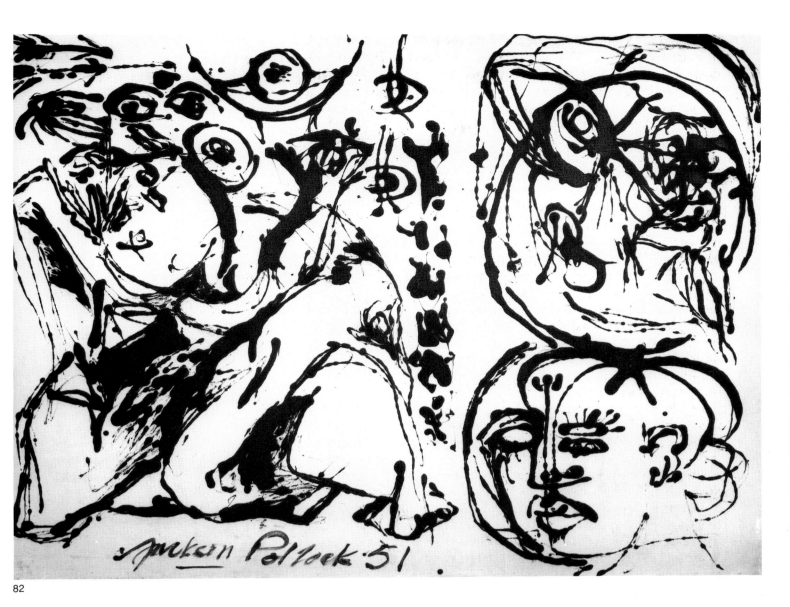

82

81. *Number 10, 1951*, 1951
Enamel on canvas, mounted on composition
board, 59⅞ x 29 in.
Private collection

82. *Number 27, 1951*, 1951
Enamel on canvas, 55¾ x 73 in.
Private collection

83. Drawing, 1951
Black and colored inks on paper, 24¾ x 39 in.
Richard E. and Jane M. Lange Collection,
Medina, Washington

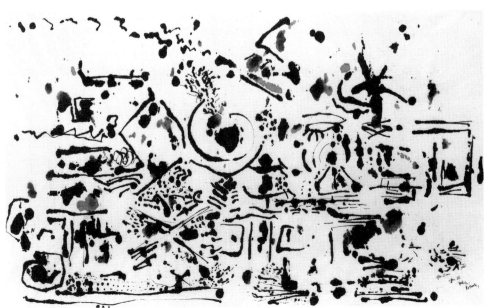

83

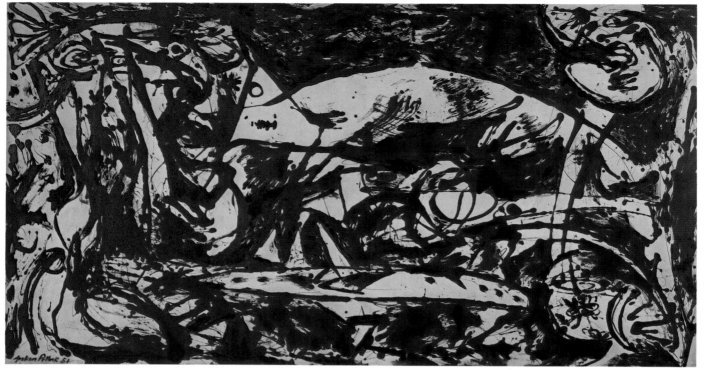

84

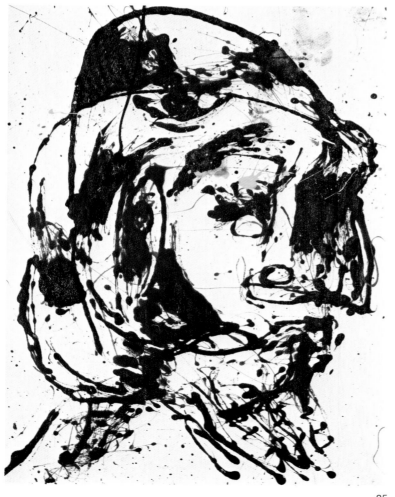

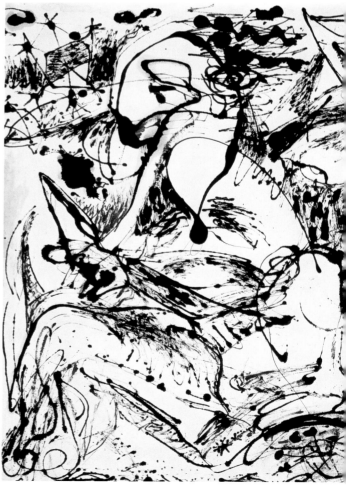

85 86

simultaneously toward and away from figuration. More than anything else, the images in the black paintings emerge from and retreat into the pigment itself, with the consequence that no matter what kind of mark or image occurs, the viewer must confront the physical coextension of paint and image (and in some cases the coextension of paint and canvas). The strange female figure embedded in *Number 5, 1952* and the mysterious central shape in *Number 14, 1951* have an inescapable material abstractness, despite their figural qualities. The head emerging from the blotches, curves, and flecks of *Number 7, 1952* is entirely nonspecific; and though the head in *Portrait and a Dream*—another two-part painting—has generally been taken to be Pollock's self-portrait, there is only minimal specificity in the features suggested by the curvilinear painterly swaths.

Despite the radical inconclusiveness of the black paintings, these works continue to elicit critical interpretation in terms of depictive and illustrational ends. E. A. Carmean, Jr., argues that Pollock's discussions with sculptor-architect Tony Smith about the possibility of doing a series of allover paintings for a large Catholic church to be designed by Smith furnish the background for seeing

84. *Number 14, 1951*, 1951
Enamel on canvas, 57⅝ x 106 in.
The Tate Gallery, London
Lent by Lee Krasner Pollock

85. *Number 7, 1952*, 1952
Enamel on canvas with touches of yellow and orange oil paint, 53⅛ x 40 in.
The Metropolitan Museum of Art
Lent by Lee Krasner Pollock

86. *Portrait and a Dream*, 1953
Oil on canvas, 58⅛ in. x 11 ft. 2½ in.
Dallas Museum of Fine Arts
Gift of Mr. and Mrs. Algur H. Meadows and the Meadows Foundation, Inc.

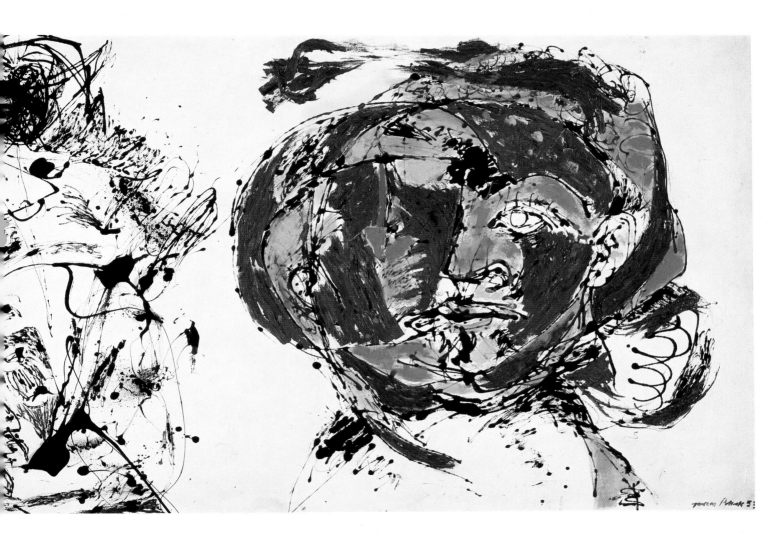

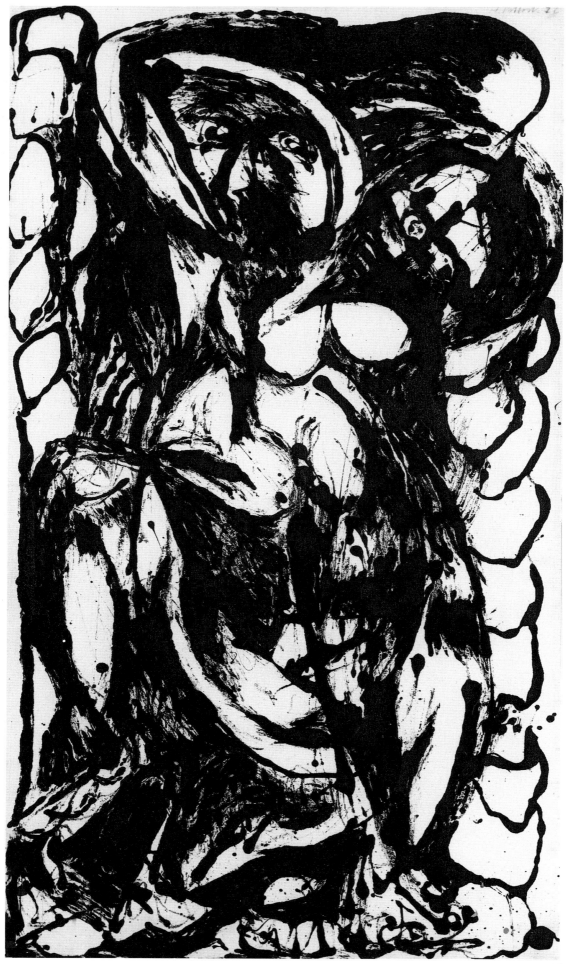

Christian motifs in a number of black paintings. Among them are *Number 5, 1952*, which Carmean sees as a Lamentation, and *Number 14, 1951*, which he reads similarly as a Crucifixion based on Picasso's 1930 *Crucifixion*.[77] To see the paintings in this way, however, trivializes or negates the logic of Pollock's development, in particular the long struggle requiring every bit of his ingenuity and intelligence to generate abstraction out of line freed from obligatory figuration. Carmean's interpretation of the black paintings further disregards Pollock's oft-repeated statements that he did not work from drawings and studies, and his equally oft-repeated statements that he worked immediately and directly from the unconscious. "I don't care for 'abstract expressionism,' . . ." Pollock once replied, when asked about how to label his painting, "and it's certainly not 'nonobjective,' and not 'nonrepresentational' either. I'm very representational some of the time, and a little all of the time. But when you're painting out of your unconscious, figures are bound to emerge."[78] There is no way to *prove* that Christian themes are absent from Pollock's black paintings, although they are not to be found in his earlier paintings. But it was uncharacteristic of him to work in terms of "themes" to begin with, particularly preestablished religious or literary themes. The very ambiguity of the images in the black paintings is precisely what generates their tantalizing indefiniteness, and to see them in fixed terms, plausible as such terms may be, is nevertheless to ignore the heterogeneous and scrambled significations yielded up by the artist's faith in his own unconscious.

The black paintings, then, take as their subject this mining of the unconscious, with the conscious intention of following through those images that the pouring technique tended to bring to the surface. The crudity and literalness of these images are utterly appropriate to Pollock's fearless dismantling of his own immediately prior achievement, evidence of his refusal to rest on his laurels or take anything for granted, least of all his own "success." To paint them Pollock had to permit a break with his own virtuosity, a break his own sense of authenticity demanded, although it swept him into regions where even his admirers could not follow.

87. *Number 5, 1952*, 1952
Enamel on canvas, 56 x 31½ in.
Lee Krasner Pollock

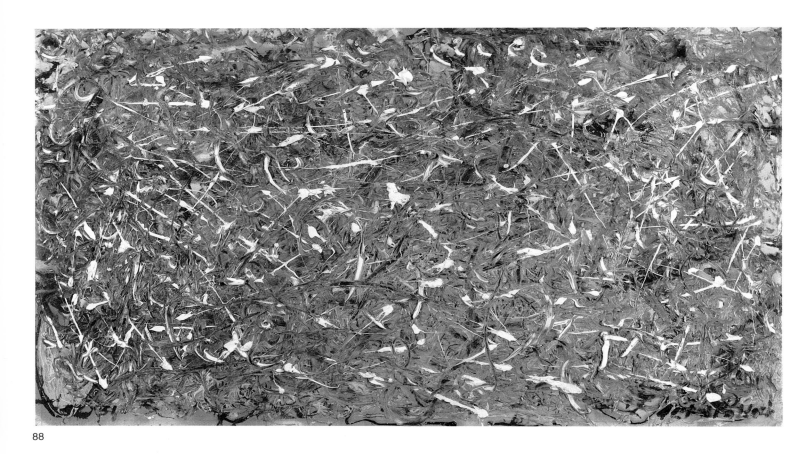

88

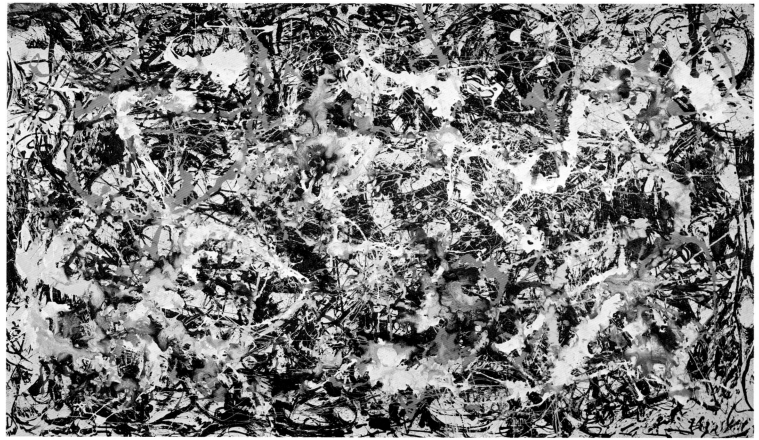

89

6 Terminus, 1953–56

Pollock continued to make good and occasionally great paintings through 1955, although his output severely diminished. The black paintings did not lead to a new development, and, for the most part, Pollock returned to the allover poured formats of the late 1940s. Friends and observers noted his anxiety about repeating himself, a problem, of course, that can afflict any serious artist, particularly one who has undergone more than ten years of spectacular and uninterrupted growth.

Pollock did not, in fact, repeat himself. Among his late paintings are some of his most inventive and assured works, paintings of marked freedom and individuality. He took chances, and did not automatically rule out possibilities, not only pouring but applying paint right from the tube in the thick impasto of *Number 28, 1951,* 88 and trailing yellow, red, blue, and white over the complex black and white network of *Convergence: Number 10, 1952.* In *Blue* 89 *Poles: Number 11, 1952,* he finally incorporated the "poles" that 90 had been one of his earliest and most persistent motifs into a major abstract statement. With their burred and bleeding edges, the poles mark out lines of force and powerful structural tensions in the labyrinthine surface.

Explicit figural elements make their way into the late paintings as well. *Ocean Greyness* contains the "eye" motifs of earlier peri- 91 ods; these emerge from the somber gray welter like grim prophecies. In *Easter and the Totem* (1953), Pollock pays homage to Matisse 1 (and perhaps to Gorky as well), situating energetic biomorphic forms in vertical sections not unlike those in Matisse's monumental *Bathers by a River.* There is subtle and unexpected lyricism in *Greyed Rainbow,* with its infusion of chromatic color in the lower 92 third of an allover poured black and white surface, and tragic power in *The Deep,* with its uncharacteristically opaque and unbroken blanket of milky paint that splits over a deep black fissure. This painting recalls a passage in *Moby Dick* that seems to summarize the continuous presence of conflict and the crucial role of emotional and structural oppositions in Pollock's work: "Hither, and thither, on high, glided the snow-white wings of small, unspeckled birds; these were the gentle thoughts of the feminine air; but to and fro in the deeps, far down in the bottomless blue, rushed mighty

88. *Number 28, 1951,* 1951
Oil on canvas, 30⅛ x 54⅛ in.
Mr. and Mrs. David Pincus

89. *Convergence: Number 10, 1952,* 1952
Oil on canvas, 93½ in. x 13 ft.
Albright-Knox Art Gallery, Buffalo, New York
Gift of Seymour H. Knox, 1956

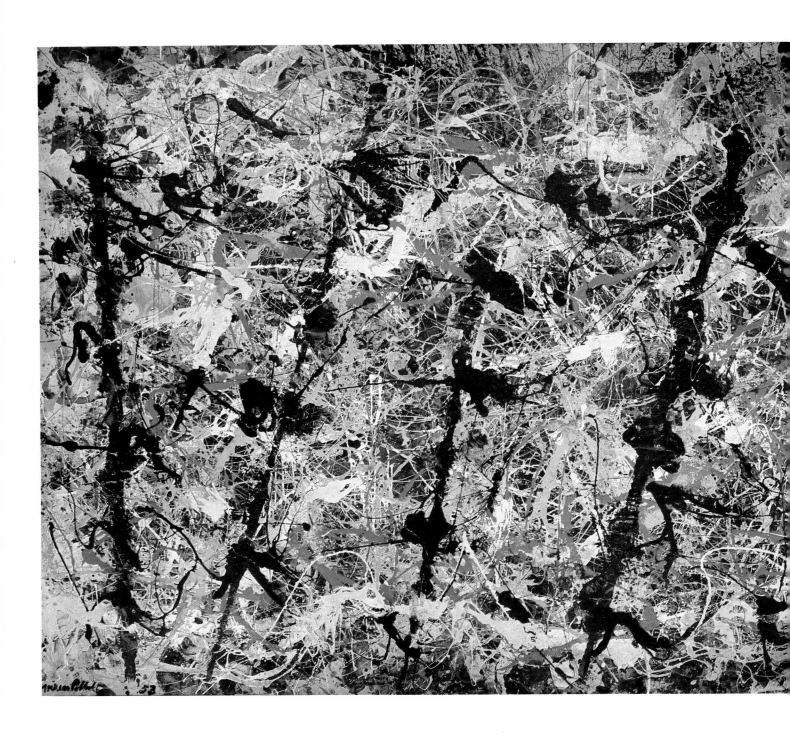

90. *Blue Poles: Number 11, 1952*, 1952
Enamel and aluminum paint with glass on canvas,
83 in. x 16 ft.
Australian National Gallery, Canberra

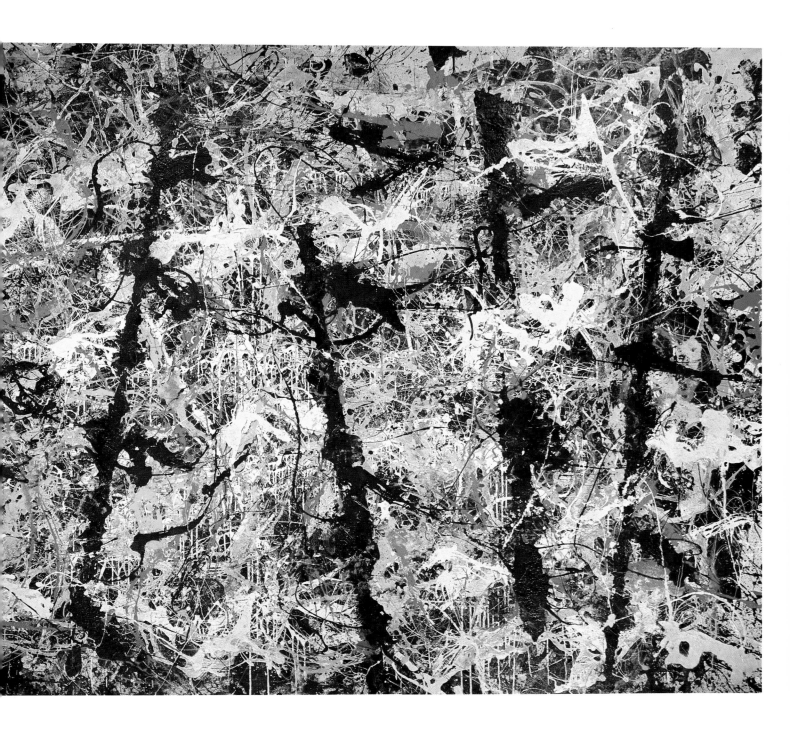

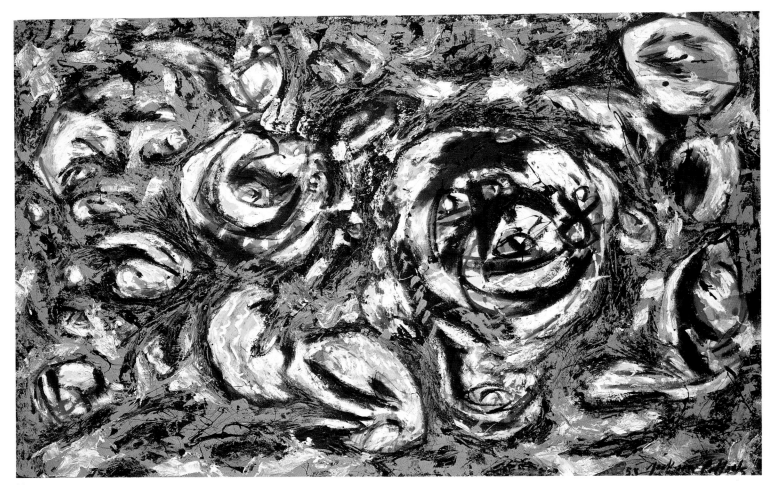

91

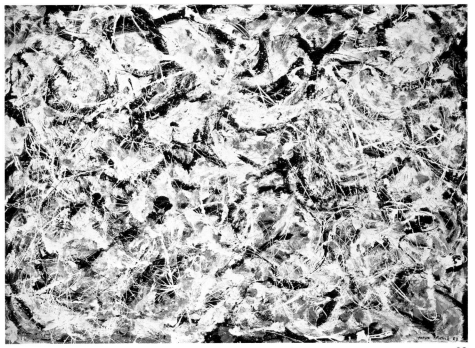

92

91. *Ocean Greyness*, 1953
Oil on canvas, 57¾ x 90⅛ in.
The Solomon R. Guggenheim Museum, New York

92. *Greyed Rainbow*, 1953
Oil on canvas, 72 x 96 in.
The Art Institute of Chicago
Gift of the Society for Contemporary American Art

93. *The Deep*, 1953
Oil and enamel on canvas, 86¾ x 59⅛ in.
Musée National d'Art Moderne, Centre Georges
Pompidou, Paris
Given in memory of John de Menil by his children
and the Menil Foundation

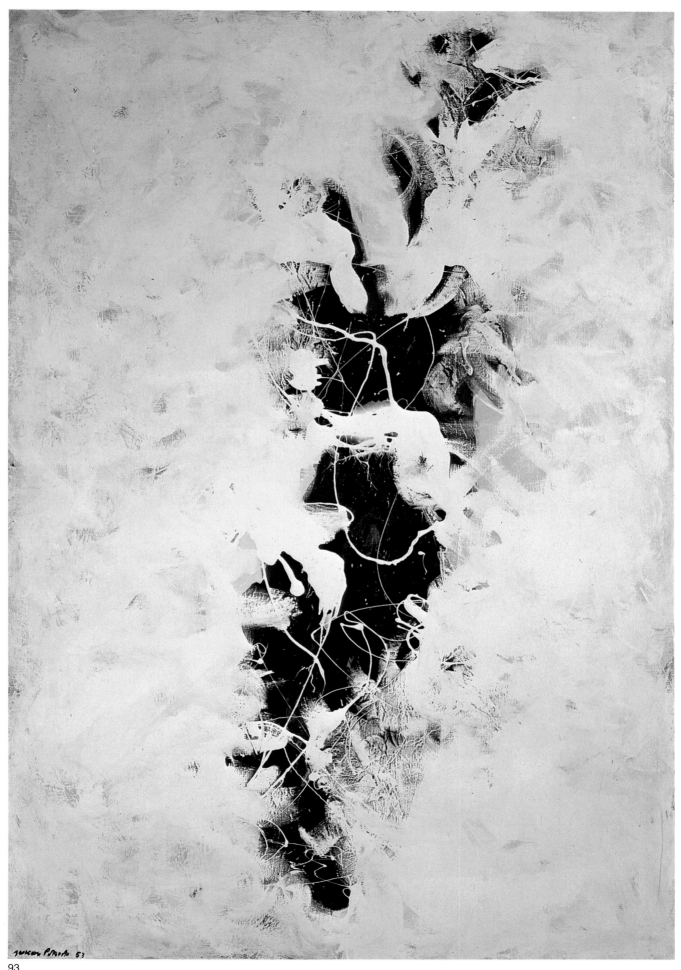

Jackson Pollock 53

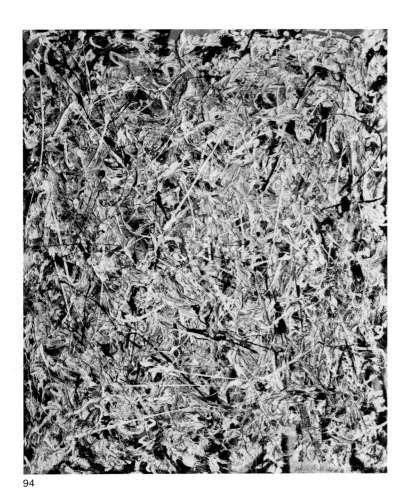

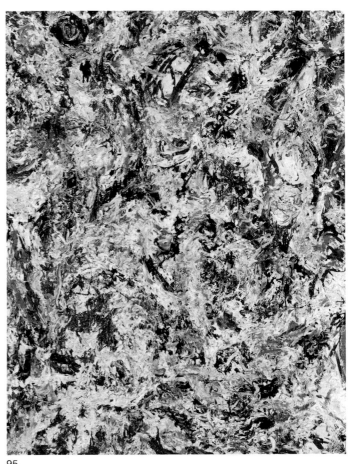

94 95

leviathans, sword-fish, and sharks; and these were the strong, troubled, murderous thinkings of the masculine sea."

Pollock's last paintings represent neither a departure nor a conclusion, while at the same time they look both forward and back. To a marked degree *White Light* and *(Scent)* revive aspects of the composition of *Eyes in the Heat*, and *Search* maps out an unexpected allover synthesis between the puddled shapes of the black paintings and the semienclosed angles and contours of his pre-1947 paintings.

By all accounts, Pollock's last months were deeply troubled. He struggled against a sense of defeat and depression, and photographs from the period show him losing the battle against the physical ravages of alcoholism. Pollock was killed instantly, at the age of forty-four, on the night of August 11, 1956, in Springs, when his car went out of control and crashed into a clump of trees. It is in the highest degree romantic and wasteful to regard his death, as some have regarded it, as a destined fulfillment of his genius. What is probably closer to the truth is that Pollock's alcoholism had finally caught up with him by severely compromising his physical coordination and mental judgment. If fate must be read into his death, it can be found only in the hideous coincidence of drunk driving and a bad bend in the road that night. Accident may be denied in art, but it cannot always be denied in life.

94, 95
50, 96

94. *White Light*, 1954
Oil, enamel, and aluminum paint on canvas,
48¼ x 38¼ in.
The Sidney and Harriet Janis Collection
Gift to The Museum of Modern Art, New York

95. *(Scent)*, c. 1953–55
Oil and enamel on canvas, 78 x 57½ in.
Marcia S. Weisman, Beverly Hills, California
The Weisman Family Collection

96. *Search*, 1955
Oil and enamel on canvas, 57½ x 90 in.
Private collection

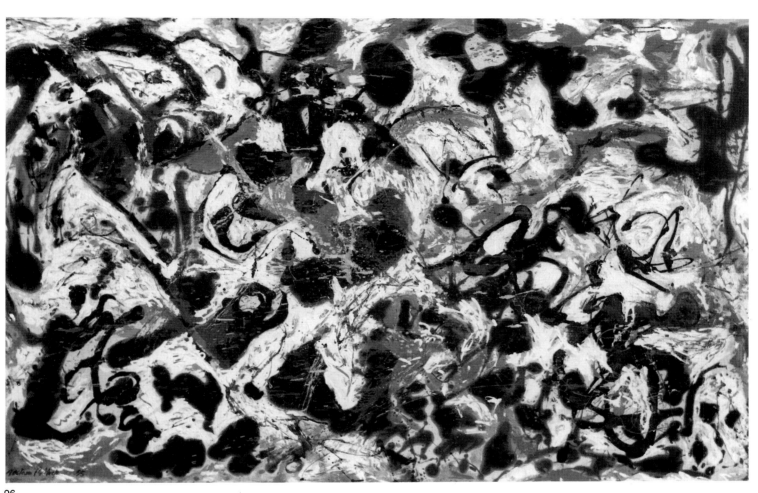

96

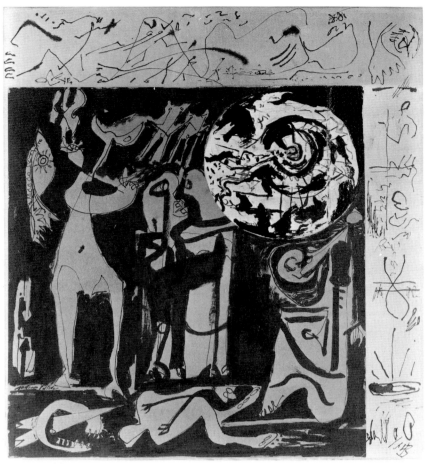

97

104

98

 Aftermath

Although Pollock lived only to the age of forty-four, he created in that time an extraordinary number of extraordinary works, including paintings, drawings, collages, and sculptures. Though it is impossible to say with any certainty what he would have done had he lived longer, surely it is wrong to see his life's work too neatly in terms of emergence, maturity, and decline. Growth and change were such essential features of his work that we ought not to regard his last paintings as ultimate statements.

The myth of Pollock as inarticulate art-cowboy no longer commands the credibility it did in the 1950s, and his greatness is assured. Painters have always looked at him and continue to do so. "... It is as if his work was the last achievement of whose status every serious artist is convinced," critic Philip Leider has written.[79] Willem de Kooning once said, "Pollock broke the ice."[80] He made it possible for American painting to compete with European modernism by applying modernism's logic to new problems. He created a new scale, a new definition of surface and touch, a new syntax of relationships among space, pigment, edge, and drawing, displacing hierarchies with an unprecedented and powerful and fabulously intricate self-generating structure. His black paintings provided Helen Frankenthaler with a point of departure for her stained paintings, which in turn influenced the color-field work of Morris Louis and Kenneth Noland. The pure confrontational power of his abstractions provided an endorsement for the aggressively frontal formats of Noland, Frank Stella, and Larry Poons, while Jasper Johns has explored alloverness at nearly every stage of his career. Other artists—Grace Hartigan, Al Held, and Alex Katz among them—first found their true vocation as artists through looking at Pollock's work and understanding its overwhelming implications as *painting*.

Only an American so solidly entrenched in his own identity that he could afford to lose sight of it could have taken American painting out of its provincial impasse and into successful rivalry with European modernism. Pollock made art out of a thorough understanding of himself and his own contradictions. He experienced "extremes of insecurity and confidence," Lee Krasner remembers:

97. *Collage*, c. 1943
Colored papers with brush, pen and ink, crayon and colored pencil brushed with water, 15½ x 13⅝ in.
Marcia S. Weisman, Beverly Hills, California
The Weisman Family Collection

98. Sculpture, c. 1949–50
Painted terracotta, length: 8 in.
Lee Krasner Pollock

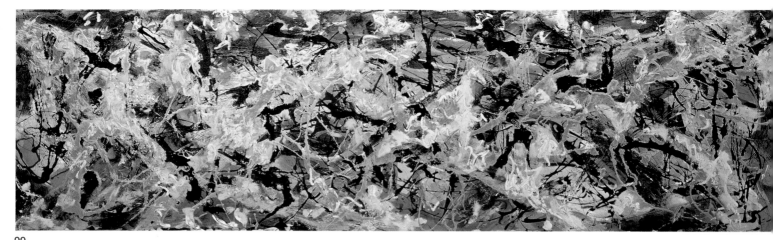

You only have to see the film of him making his painting on glass (*Number 29, 1950*) to know how sure he was of himself: the way he wipes out the first start and begins over. But there were other times when he was just as unsure. A little later, in front of a very good painting—not a black-and-white—he asked me, "Is this a painting?" Not is this a good painting, or a bad one, but a painting! The degree of doubt was unbelievable at times.[81]

Pollock knew that working out of his unconscious meant much more than relying upon psychic automatism as a technique. It meant facing these extremes of assurance and doubt, riding with them, trusting them without having to believe in them absolutely. "Speaking of his paintings," William S. Lieberman writes, "Jackson said more than once that they came from nowhere."[82] That is, they came from the unconscious, perhaps from its most inaccessible layers. As a man Pollock was, his wife remembers, "lucid, intelligent";[83] he believed in working, not talking. Tony Smith remembered him as not just sincere but "puritanical . . . I mean stern. . . ,"[84] a description that once again brings up Pollock's Calvinist inheritance, diffused and subterranean as it may have been. In Pollock's case the Calvinist imperatives got translated into a personal commitment to test the raw American self against the worldly European tradition, to submit to what literary critic Harold Bloom calls "the anxiety of influence." Pollock understood, as his American literary forebears Melville, Hawthorne, and Poe had understood, the "blackness of darkness": that the culture he came from—no matter how rough and unrefined it may have seemed to outsiders—was obsessed with the drama of conscience and consciousness, of desire and restraint, and that this American moral chiaroscuro predicted an eternal dissatisfaction with "success."

Pollock's paintings reveal a man capable of failure as well as magnificent achievement, but never of aesthetic lying. Each painting is an assault on the recalcitrance of inanimate materials and the arbitrariness of human conventions. In the effort to transform that arbitrariness into meaning, feeling, and necessity, and to create order, joy, grace, and heroic calm out of the limitations of that sign system called "the picture," Pollock journeyed to his spirit's interior, and his art bears witness to what he found within.

99. (*Frieze*), 1953–55
Oil on canvas, 26 x 86 in.
Mr. and Mrs. Burton Tremaine,
Meriden, Connecticut

NOTES

1. See "A *Life* Round Table on Modern Art," *Life*, October 11, 1948, pp. 56–70, 75–79, for these and other opinions.

2. "The Wild Ones," *Time*, February 20, 1956, pp. 70–75.

3. Francis V. O'Connor, "The Life of Jackson Pollock, 1912–1956: A Documentary Chronology," in Francis Valentine O'Connor and Eugene Victor Thaw, eds., *Jackson Pollock: A Catalogue Raisonné of Paintings, Drawings, and Other Works*, vol. 4, p. 203. All citations to the "Documentary Chronology" are hereafter abbreviated to DC with page number.

4. Quoted in Francine du Plessix and Cleve Gray, "Who Was Jackson Pollock?" p. 50.

5. DC, p. 206.

6. Ibid., p. 207.

7. Ibid., p. 208.

8. Ibid.

9. Ibid., p. 209.

10. Barbara Rose, *American Art since 1900: A Critical History* (New York: Praeger, 1967), p. 87.

11. For a detailed discussion of Benton's influence on Pollock see Stephen Polcari, "Jackson Pollock and Thomas Hart Benton," pp. 120–24.

12. Thomas Hart Benton, *An Artist in America*, 3rd rev. ed. (Columbia: University of Missouri Press, 1968), pp. 332–33.

13. DC, p. 217.

14. Ibid.

15. Jackson Pollock, *Arts and Architecture*, p. 14.

16. Ibid.

17. John Graham, *System and Dialectics of Art*, annotated by Marcia Epstein Allentuck (Baltimore: Johns Hopkins Press, 1971), p. 134.

18. Ibid. See note, p. 135.

19. John Graham, "Primitive Art and Picasso," *Magazine of Art* 30 (April 1937): 237.

20. See Judith Wolfe, "Jungian Aspects of Jackson Pollock's Imagery," pp. 66–67.

21. See, for example, David Freke, "Jackson Pollock: A Symbolic Self-Portrait," pp. 217–21; Elizabeth L. Langhorne, "Jackson Pollock's 'The Moon Woman Cuts the Circle,'" pp. 128–37; and Jonathan Welch, "Jackson Pollock's 'The White Angel,'" pp. 138–41.

22. Both quoted in Donald E. Gordon, "Department of Jungian Amplification, One: Pollock's 'Bird,' or How Jung Did Not Offer Much Help in Myth-Making," p. 44.

23. Ibid.

24. Ibid.

25. Selden Rodman, *Conversations with Artists* (New York: Capricorn Books, 1961), p. 82.

26. John Bernard Myers, "Surrealism and New York Painting 1940–1948: A Reminiscence," *Artforum* 15 (April 1977): 56.

27. Rosalind Krauss, "Jackson Pollock's Drawings," p. 61.

28. Clement Greenberg, "The Late Thirties in New York," in *Art and Culture: Critical Essays* (Boston: Beacon Press, 1961), pp. 232–33.

29. DC, p. 225.

30. Ibid., p. 226.

31. Lee Krasner Pollock, conversation with the author, February 11, 1983, New York.

32. DC, p. 226.

33. Ibid.

34. Lee Krasner Pollock, conversation with the author.

35. Clement Greenberg, "Marc Chagall, Lyonel Feininger, Jackson Pollock," *The Nation* 157 (November 27, 1943): 621.

36. B. H. Friedman, "An Interview with Lee Krasner Pollock by B. H. Friedman," in William S. Lieberman, introduction, *Jackson Pollock: Black and White*, p. 7.

37. Lee Krasner Pollock, telephone conversation with the author, March 13, 1983.

38. For further discussion and controversy concerning Pollock's iconography, see Wolfe, "Jungian Aspects," and William Rubin, "Pollock as Jungian Illustrator: The Limits of Psychological Criticism," part 1, November 1979, pp. 104–23.

39. Again, for extended discussion of the Jungian interpretation of this painting see Langhorne, "Jackson Pollock's *The Moon Woman Cuts the Circle*," and Rubin, ibid.

40. Clement Greenberg, "Wassily Kandinsky, Piet Mondrian, Jackson Pollock," *The Nation* 160 (April 7, 1945): 397.

41. Ibid.

42. Quoted in DC, p. 232.

43. Ibid.

44. Quoted in du Plessix and Gray, "Who Was Jackson Pollock?" p. 50.

45. William Rubin, "Jackson Pollock and the Modern Tradition," part 1, February 1967, p. 18.

46. Clement Greenberg, "Jean Dubuffet, Jackson Pollock," *The Nation* 164 (February 1, 1947): 137.

47. DC, p. 238.

48. For the definitive analysis of the genesis of Pollock's allover "drip" or "poured" paintings, see William Rubin's four-part article, "Jackson Pollock and the Modern Tradition." Hereafter cited as Rubin, JPMT.

49. Rubin, JPMT, part 4, May 1967, p. 31.

50. Clement Greenberg, "American-Type Painting," in *Art and Culture*, p. 218.

51. Rubin, JPMT, part 4, May 1967, p. 31.

52. From taped interview with William Wright.

53. Jackson Pollock, "My Painting," p. 79.

54. Michael Fried, *Three American Painters: Kenneth Noland, Jules Olitski, Frank Stella*, exhibition catalog, Cambridge, Mass.: Fogg Art Museum, p. 14.

55. Ibid.

56. Frank O'Hara, *Jackson Pollock*, p. 26.

57. Rubin, JPMT, part 3, April 1967, p. 31, note 2.

58. Greenberg, "American-Type Painting," p. 218; quoted in Rubin, JPMT, part 3, April 1967, p. 19.

59. "Unframed Space," *New Yorker* (August 5, 1950); quoted in B. H. Friedman, *Jackson Pollock: Energy Made Visible*, p. 157.

60. Both the Alfieri piece and the *Time* article are quoted ibid., pp. 158, 160.

61. Ibid., p. 160.

62. Barbara Rose, "Introduction—Jackson Pollock: The Artist as Culture Hero," in *Pollock Painting: Photographs by Hans Namuth*, ed. Barbara Rose (New York: Agrinde Publications, 1978), unpaginated.

63. Interview with William Wright, DC, p. 251.

64. For a discussion of the consequences of the widespread cultural misreading of Namuth's photographs, see Rosalind Krauss, "Reading Photographs as Text," in *Pollock Painting*, n.p.

65. Harold Rosenberg, "The American Action Painters," *Artnews* 51 (December 1952): 22. Reprinted in *The Tradition of the New* (New York: McGraw-Hill, 1965), p. 25.

66. "Jackson Pollock: An Artists' Symposium, Part One," p. 60.

67. Italo Tomassoni, *Pollock* (New York: Grosset & Dunlap, 1978), p. 5.

68. DC, p. 261.

69. Greenberg, "American-Type Painting," p. 228.

70. Fried, *Three American Painters*, p. 15.

71. Francis V. O'Connor, *Jackson Pollock: The Black Pourings 1951–1953*, p. 2.

72. Friedman, "Interview with Lee Krasner," p. 7.

73. Ibid., pp. 8, 10, for technical information on the black paintings.

74. Ibid., p. 8.

75. Ibid., p. 7.

76. Lawrence Alloway, "Jackson Pollock's Black Paintings," pp. 40–43.

77. For details see E. A. Carmean, "The Church Project: Pollock's Passion Themes," pp. 110–22. For a refutation of Carmean's view see Rosalind Krauss, "Contra Carmean: The Abstract Pollock," pp. 123–31, 155.

78. Rodman, *Conversations with Artists*, p. 82.

79. Philip Leider, "Literalism and Abstraction," *Artforum* 8 (April 1970): 44.

80. Quoted in Friedman, *Energy Made Visible*, p. 253.

81. Friedman, "Interview with Lee Krasner Pollock," p. 8.

82. William S. Lieberman, "Pollock's Last Sketchbook," p. 19 of typescript. Metropolitan Museum of Art. Quoted here by kind permission of William S. Lieberman.

83. du Plessix and Gray, "Who Was Jackson Pollock?" p. 51.

84. Ibid., p. 53.

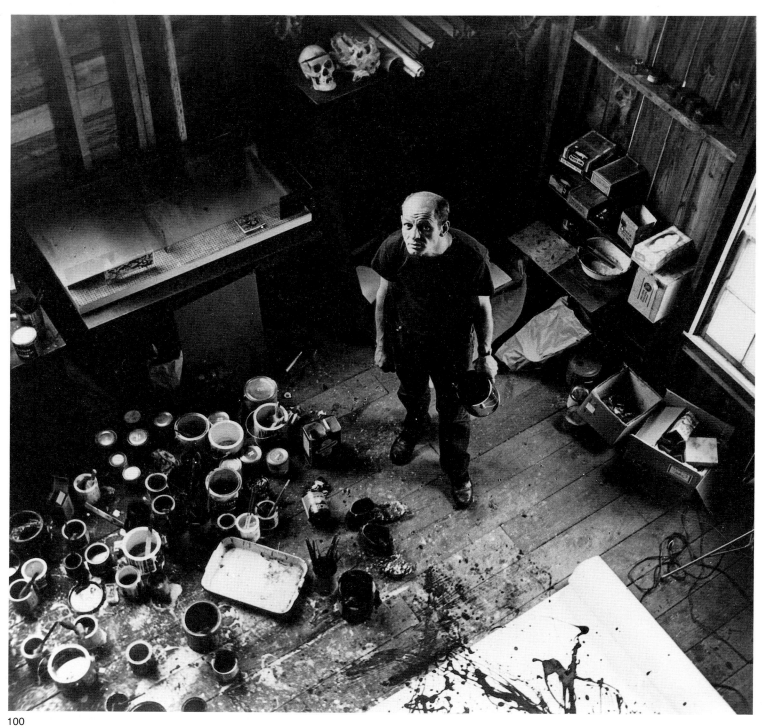

100

Artist's Statements

Do you think there can be a purely American art?

The idea of an isolated American painting, so popular in this country during the 'thirties, seems absurd to me, just as the idea of creating a purely American mathematics or physics would seem absurd. . . . And in another sense, the problem doesn't exist at all; or, if it did, would solve itself: An American is an American and his painting would naturally be qualified by that fact, whether he wills it or not. But the basic problems of contemporary painting are independent of any one country.

Arts and Architecture (February 1944), p. 14.

My painting does not come from the easel. I hardly ever stretch my canvas before painting. I prefer to tack the unstretched canvas to the hard wall or the floor. I need the resistance of a hard surface. On the floor I am more at ease. I feel nearer, more a part of the painting, since this way I can walk around it, work from the four sides and literally be *in* the painting. This is akin to the method of the Indian sand painters of the West.

I continue to get further away from the usual painter's tools such as easel, palette, brushes, etc. I prefer sticks, trowels, knives, and dripping fluid paint or a heavy impasto with sand, broken glass, and other foreign matter added.

When I am *in* my painting, I'm not aware of what I am doing. It is only after a sort of "get acquainted" period that I see what I have been about. I have no fears about making changes, destroying the image, etc., because the painting has a life of its own. I try to let it come through. It is only when I lose contact with the painting that the result is a mess. Otherwise there is pure harmony, an easy give and take, and the painting comes out well.

Possibilities (Winter 1947), p. 79.

There was a reviewer a while back who wrote that my pictures didn't have any beginning or any end. He didn't mean it as a compliment, but it was. It was a fine compliment. Only he didn't know it.

"Unframed Space," *New Yorker* (August 5, 1950), p. 16.

Mr. Pollock, in your opinion, what is the meaning of modern art?

Modern art to me is nothing more than the expression of contemporary aims of the age that we're living in.

100. Jackson Pollock in his studio
Photograph by Rudolph Burckhardt

Did the classical artists have any means of expressing their age?

Yes, they did it very well. All cultures have had means and techniques of expressing their immediate aims—the Chinese, the Renaissance, all cultures. The thing that interests me is that today painters do not have to go to a subject matter outside of themselves. Most modern painters work from a different source. They work from within. . . .

Mr. Pollock, there's been a good deal of controversy and a great many comments have been made regarding your method of painting. Is there something you'd like to tell us about that?

My opinion is that new needs need new techniques. And the modern artists have found new ways and new means of making their statements. It seems to me that the modern painter cannot express this age, the airplane, the atom bomb, the radio, in the old forms of the Renaissance or of any other past culture. Each age finds its own technique. . . .

I suppose every time you are approached by a layman they ask you how they should look at a Pollock painting, or any other modern painting—what they look for—how do they learn to appreciate modern art?

I think they should not look for, but look passively—and try to receive what the painting has to offer and not bring a subject matter or preconceived idea of what they are to be looking for. . . .

Then deliberately looking for any known meaning or object in an abstract painting would distract you immediately from ever appreciating it as you should?

I think it should be enjoyed just as music is enjoyed—after a while you may like it or you may not. But—it doesn't seem to be too serious. I like some flowers and others, other flowers, I don't like. I think at least it gives—I think at least give it a chance. . . .

Mr. Pollock, the classical artists had a world to express and they did so by representing the objects in that world. Why doesn't the modern artist do the same thing?

H'm—the modern artist is living in a mechanical age and we have a mechanical means of representing objects in nature such as the camera and photograph. The modern artist, it seems to me, is working and expressing an inner world—in other words— expressing the energy, the motion, and other inner forces.

Would it be possible to say that the classical artist expressed his world by representing the objects, whereas the modern artist expresses his world by representing the effects the objects have upon him?

Yes, the modern artist is working with space and time, and expressing his feelings rather than illustrating. . . .

Shall we go back to this method question that so many people today think is important? Can you tell us how you developed your method of painting, and why you paint as you do?

Well, method is, it seems to me, a natural growth out of a need, and from a need the modern artist has found new ways of expressing the world about him. I happen to find ways that are different from the usual techniques of painting, which seems a

Notes on Technique

Up until the early 1940s, Pollock held to easel formats, painting with brushes and working primarily in oil on canvas, although sometimes he used the rough or smooth side of Masonite, gessoboard, tin, and wood panel. According to Lee Krasner, when she first met Pollock he had an easel in his studio, but preferred to paint on the floor.[1] His large 1942 paintings show him beginning to experiment with a wide range of open, painterly effects, including dripping and spattering, obtained with sticks and knives. In 1943 he made a number of poured paintings both in oil and in oil and enamel on canvas. His allover technique (as distinct from pouring) evolved over the years 1942–46, reaching its most advanced form in the impasto works of the Sounds in the Grass series (1946), among them *Eyes in the Heat* and *Shimmering Substance.* Pollock was still inhibited by traditional drawing, remnants of which compromised the spontaneity and directness he was searching for, and in 1946–47, in order to overcome this problem, he made the full transition to dripping and pouring. He now tacked sized but unprimed pieces of canvas to the floor, worked from all four sides, and used sticks and hardened brushes, which did not themselves touch the surface of the painting. In addition to oil, he used commercial enamels and aluminum paint, constructing extraordinarily dense webs and skeins from the flung and fluid paint. "Controlled pouring could thicken, thin and articulate the line at will *in a way a loaded stick or brush could not*," writes William Rubin, "The thinned oil paint and commercial enamels he employed could be used over large spaces without creating a surface burdened with a bas-relief of impasto. With the drag of the brush eliminated, the spontaneity of Pollock's drawing could reach a new point and the anatomy of his line a new variety."[2]

Contrary to popular belief, not all of the poured paintings were uniformly mural sized. Pollock wanted to make paintings out of a "halfway state" between the mural and the easel scale, and some of his widest pictures, *Lucifer*, for instance, are under 50 inches in height, while others, among them *Number 5, 1948*, are under 50 inches in width. Some of the poured paintings are smaller than 50 inches in both dimensions, and even one of his widest paintings, *Summertime: Number 9A, 1948*, which is 18 feet 2 inches wide, is only 33¼ inches high.

101. Jackson Pollock painting *Number 32, 1950*. Photograph by Rudolph Burckhardt

Pollock's brushes were hardened by being allowed to dry in cans of paint (sometimes they were so hard that, as Lee Krasner recalls, when Hans Hofmann once visited Pollock's studio, he picked up a brush in a paint can and was surprised when the entire can lifted up. "My God," he exclaimed, "with this you could kill a man!"[3]). But the control was strict with these brushes. By placing the canvas on the floor Pollock could both outwit and exploit the force of gravity: there was no running-off and no marbleizing. Pollock could rely not just on his arm and hand but on the leverage of his entire body to determine where the paint would go. As the Namuth-Falkenberg film shows, sometimes he poured paint directly from the can. When working with sticks he would put the stick in a can, tilt the can, and let the pigment run down the stick onto the canvas. Sometimes he applied paint directly from the tube; sometimes he put paint on his hands and made prints directly on the canvas.

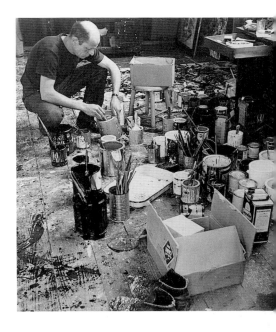

With his black paintings Pollock used almost identical techniques and materials. He used rolls of cotton duck, as he had since the early 1940s: "He would order remnants, bolts of canvas anywhere from five to nine feet high, having maybe fifty or a hundred yards left on them—commercial duck, used for ships and upholstery, from John Boyle down on Duane Street,"[4] Lee Krasner recalls. He would then roll out a stretch of this canvas on the studio floor, up to twenty feet at a time. The weight of the canvas would hold it down, so that he didn't have to tack it. He would then size the canvas with one or two coats of 'Rivit' glue; in the case of some of the black paintings, he sized them after they were finished, in order to seal them. He used black industrial enamel, for the most part, in the black paintings: Duco or Davoe & Reynolds. After thinning this enamel to the desired consistency, he would apply it with sticks, hardened or wornout brushes, and basting syringes. Lee Krasner observes, "His control was amazing. Using a stick was difficult enough, but the basting syringe was like a giant fountain pen. With it he had to control the flow of ink as well as his gesture. He used to buy those syringes by the dozen. . . ."[5] With the larger black paintings he would either complete one and cut it off the roll of canvas, or cut it off in advance and work on it; with the smaller black paintings he would often paint several on a large strip of canvas and then cut that strip from the roll: "Sometimes he'd ask, 'Should I cut it here? Should this be the bottom?' He'd have long sessions of cutting and editing, some of which I was in on, but the final decisions were always his. Working around the canvas—in 'the arena' as he called it—there really was no absolute top or bottom. And leaving space between paintings, there was no absolute 'frame' the way there is working on a prestretched canvas."[6] Occasionally he would decide to treat two or more successive panels as one painting, as a diptych or triptych, for example *Portrait and a Dream*.

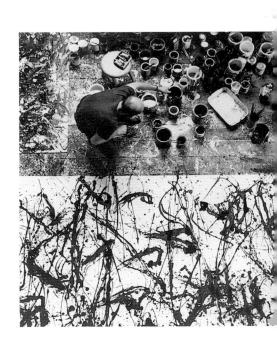

In his drawings and works on paper, which were an integral part of his working life, Pollock used a wide variety of media: pencil, crayon, colored pencil, ink, gouache, tempera, watercolor, pastel, chalk, and enamel, alone and in combination. He worked on sketchbook sheets; textured, lined, and colored paper; Japanese

86

paper; and other fine handmade papers. He made a number of collages, including some in 1948–49 with cutout figures, and one in enamel and aluminum paint: *Number 29, 1950*, the work that Namuth filmed Pollock painting.

As a young man Pollock had aspired to be a sculptor, and had worked in stone, carved wood, and oxidized copper. He made a large abstract mosaic (c. 1938–41) and, in 1949, three small three-dimensional representations of his pouring technique in wire dipped in plaster and splattered with paint (two of these have since been lost). He also made two abstract sculptures, again related to his allover drawing, in painted terra-cotta.

Pollock made lithographs in the 1930s of his Regionalist motifs, and from the fall of 1944 to the spring of 1945 made some eleven engravings at Stanley William Hayter's Atelier 17 in New York. These included abstract and semifigurative motifs, a number of which were encompassed by sharp allover lines and rhythms that appear to have had a strong influence on the abstract poured paintings that followed within the next two years.

1. Lee Krasner Pollock, conversation with the author, February 11, 1983, New York.
2. William Rubin, "Jackson Pollock and the Modern Tradition," part 1, February 1967, p. 19.
3. Lee Krasner Pollock, conversation with the author.
4. B. H. Friedman, "An Interview with Lee Krasner Pollock by B. H. Friedman," in William S. Lieberman, introduction, *Jackson Pollock: Black and White*, p. 8. This text should be referred to for additional technical details.
5. Ibid., p. 10.
6. Ibid.

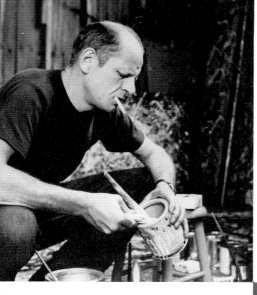

102-5. Jackson Pollock in the studio with *Number 32, 1950*
Photographs by Rudolph Burckhardt

106. Jackson Pollock, c. 1928

Chronology By Anna Brooke

1912 January 28—Paul Jackson Pollock, fifth and youngest son, born to Stella May McClure Pollock and LeRoy Pollock in Cody, Wyoming. Brothers are Charles Cecil, Marvin Jay, Frank Leslie, and Sanford Leroy. Father is a stone-mason and cement worker. November 28—family moves to San Diego, California.

1913 August—family moves to Phoenix, Arizona. Father buys a truck farm.

1917 Farm is sold at auction. Family moves to Chico, California. Sometime before 1922 family moves to Janesville, California.

1922 Family moves to Orland, California, to a farm. Charles leaves home to work for the *Los Angeles Times* and study at Otis Art Institute, Los Angeles. He sends home copies of *The Dial* and *American Mercury*.

1923 Fall—family moves to a farm outside Phoenix, Arizona. September—attends Monroe Elementary School in Phoenix until February 1924. Tip of right finger is cut off accidentally.

1924 Spring—family moves to Chico, California. Later family moves to Riverside, near Los Angeles.

1926 September—Charles registers at Art Students League, New York, and studies with Thomas Hart Benton.

1927 Summer—with brother Sanford, works as surveyor at Grand Canyon. September—attends Riverside High School.

1928 March—expelled from Riverside High School. Summer—family moves to Los Angeles. Fall—enrolls at Manual Arts High School. Influ-

This chronology is indebted, as all future Pollock chronologies must be, to the extensive research published by Francis V. O'Connor in the "Documentary Chronology," of the Pollock catalogue raisonné. A. B.

enced by art teacher, Frederick John de St. Vrain Schwankovsky, who introduces him to theosophy. Meets Philip Guston and Manuel Tolegian. Uses name *Hugo*. Is expelled sometime during the year.

1929 Summer—works with his father at Santa Ynez on a surveying and road construction gang. Fall—returns to Manual Arts High School where he studies life drawing and clay modeling; soon expelled again. Admires the work of Diego Rivera.

1930 Spring—enrolls parttime at Manual Arts High School. June—sees José Clemente Orozco's fresco, *Prometheus*, at Pomona College. Fall—goes to New York with brothers Charles and Frank. Drops name *Paul* and uses *Jackson*. September 29—enrolls at Art Students League in a class with Thomas Hart Benton. Lives at 240 West Fourteenth Street. Briefly studies sculpture at Greenwich House and with stone-carver, Ahron Ben-Schmuel. October—does "action posing" for Benton's mural at New School for Social Research; probably meets José Clemente Orozco, who is also doing a mural there.

1931 February—receives student aid. Enrolls in Benton's class. June—with Manuel Tolegian, again a fellow student, hitchhikes home to Los Angeles; arrives in July. Summer—works at Big Pines as a lumberjack. Fall—returns to New York. October—registers in Benton's mural-painting class. Receives tuition loan. Lives at 49 East Tenth Street.

1932 Summer—makes sketching trip to Los Angeles with fellow student Whitney Darrow, Jr. Sees David Alfaro Siqueiros's murals at Chouinard Art School. Fall—returns to New York by car. Registers in Benton's mural-painting class; appointed monitor and receives free tuition. Lives at 46 Carmine Street. December—becomes member of the Art Students League (until December 1935). Makes lithographs about this time, which are printed after 1934 by Theodore Wahl.

1933 January—registers in John Sloan's life-drawing class and in a sculpture class at Greenwich House. February–March—registers in Robert Laurent's sculpture class. March 6—father dies. Moves into 46 East Eighth Street with Charles and his wife, Elizabeth. Spring–summer—leaves the Art Students League; studies with Ahron Ben-Schmuel. Fall—attends Benton's musical Monday evenings (through spring 1935).

1934 Makes experimental mural sketch for Greenwich House, which is never executed. Summer—travels with Charles in a Model-T Ford to Los Angeles and back. Visits the Bentons for a few weeks at Chilmark, Martha's Vineyard, Massachusetts (each summer through 1937). Moves to 76 West Houston Street. Sanford joins him; both work as janitors at the City and Country School and are on relief. Caroline Pratt, the director, and Helen Marot, a teacher, provide encouragement. December—helps Rita Benton organize exhibition in basement of Ferargil Gallery and sells painted plates and bowls.

1935 February—is included in first group exhibition, *Eighth Exhibition of Watercolors, Pastels, and Drawings by American and French Artists*, Brooklyn Museum. Employed through the Emergency Relief Bureau as stonecutter to restore public monuments; cleans Augustus Saint-Gaudens's statue of Peter Cooper in Cooper Square. August—signs up for the mural division of the Federal Art Project of the Works Progress Administration (until 1936). Moves into 46 East Eighth Street with Sanford after Charles moves to Washington, D.C.

1936 Joins easel division of WPA (until 1943). Spring—while working at Siqueiros's workshop on Union Square is influenced by his experimental techniques and materials, including spray guns, airbrushes, and synthetic paints and lacquers. Meets Lenore Krassner (later Krasner) at a party; meets her again in 1941. Fall—rents a house in New Jersey for a few weeks.

1937 Begins psychiatric treatment for alcoholism. After April—meets artist John Graham. Charles moves to Detroit. December—visits Benton in Kansas City, Missouri.

1938 January—returns to New York via Detroit, where he visits Charles. June—employment with WPA ends due to his absences. June–September—enters the Westchester Division of the New York Hospital, where he receives treatment from Dr. James Wall for alcoholism. November 23—is reassigned to the WPA's easel division.

1939 Enters psychoanalysis with Dr. Joseph L. Henderson, a Jungian (until summer 1940); drawings are used as therapy. Summer—rents house in Bucks County, Pennsylvania, with Sanford.

1940 May—fired from the WPA under new rules; is rehired in October. Registers for draft, but is declared 4-F. Summer—Dr. Henderson leaves New York City for San Francisco.

1941 Spring—begins treatment with Henderson's assistant, Dr. Violet Staub de Laszlo, also a Jungian (through 1942). November—at John Graham's invitation is included in show held at McMillen Inc. in January 1942; begins friendship with Lee Krasner.

1942 May—signs petition to President Roosevelt protesting decline of creativity on WPA easel project. Summer—assigned to Lee Krasner's window-display project under the War Services Division of the WPA. Meets Robert Motherwell about this time through William Baziotes. Fall—Lee Krasner lives with him at 46 East Eighth Street.

1943 January—end of the WPA program. Paints neckties and decorates lipsticks. May—works as janitor at Museum of Non-Objective Painting. Meets Peggy Guggenheim. Works on collages with Robert Motherwell for an exhibition at Peggy Guggenheim's Art of This Century. She gives him a contract and commissions a mural painting for her house. Summer—returns to painting full-time. August—consults Dr. Elizabeth Wright Hubbard, a homeopathic physician (until his death). November—first solo exhibition, held at Art of This Century. Meets Stanley William Hayter, graphic artist.

1944 Museum of Modern Art buys *The She-Wolf*, first purchase of his work by a museum. Summer—rents studio in Provincetown with Lee Krasner. Fall—experiments with graphic art at Stanley Hayter's Atelier 17, where André Masson is also working.

1945 Fall—buys farmhouse in Springs, Long Island. October 25—marries Lee Krasner. November—they move to Springs.

1946 Designs dust jacket for Peggy Guggenheim's book, *Out of This Century*. Summer—remodels barn in Springs to make a studio. December—included in *Annual Exhibition of Contemporary American Paintings*, Whitney Museum of American Art, New York.

Late 1946–47 Makes first "allover" poured paintings.

1947 Applies for a Guggenheim Fellowship. December—signs contract with art dealer Betty Parsons (through June 1949). Experiments with adding sand, broken glass, and other foreign matter to heavily impastoed paint, and with using knives, sticks, and trowels.

1948 Suffers financial problems. May—included in Venice Biennale. Attends protest meeting at Museum of Modern Art against certain art critics. June—receives grant income from Ebsen Demarest Trust Fund for one year, at recommendation of James Johnson Sweeney. Is treated for alcoholism by Dr. Edwin Heller of East Hampton. Late fall—stops drinking.

1949 June—renews contract with Betty Parsons (until January 1952). Winter—makes several abstract terra-cotta sculptures in East Hampton with potter Rosanne Larkin. Meets Alfonso Ossorio about this time.

1950 Winter–spring—lives in Alfonso Ossorio's house at 9 MacDougal Alley, New York. Spring—returns to Long Island. Completes mural for Geller House, Lawrence, Long Island. May—signs letter with seventeen other artists, "The Irascibles," to the Metropolitan Museum of Art president, Roland L. Redmond, refusing to participate in the exhibition *American Painting Today 1950* because the jury was hostile to advanced art. Makes drawings on single sheets of Japanese paper. September and October—Hans Namuth makes film of Pollock painting, which opens June 14, 1951, at the Museum of Modern Art. October—begins drinking again.

1951 February 9–10—flies to Chicago to serve on a jury with Max Weber and James Lechay of the Momentum group, artists against the anti-abstract art policies of the Art Institute of Chicago. September—begins biochemical treatment for alcoholism with Dr. Grant Mark (until fall 1953). October—included in first *Bienal de São Paolo*, Museu de Arte Moderna, São Paulo, Brazil. Winter—meets Douglass M. Howell and begins to use his handmade papers. Returns to figuration.

1952 March—first solo exhibition held in Europe, at Studio Paul Facchetti, Paris. May—leaves Betty Parsons; joins Sidney Janis Gallery. November—first retrospective exhibition, held at Bennington College.

1954 Paints few works for a year and a half.

1955 Summer—begins analysis with Ralph Klein in New York City. Frequents Cedar Bar.

1956 July—Lee goes to Europe. August 11—dies in a car accident in Springs.

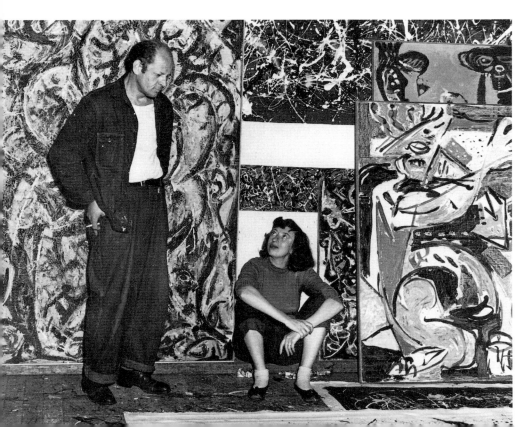

107. Jackson Pollock and Lee Krasner at the Springs.

Exhibitions

Solo Exhibitions

1943

Jackson Pollock: Paintings and Drawings, Art of This Century, New York, November 9–27.

1945

Jackson Pollock, Arts Club of Chicago, March 5–31, and tour to San Francisco Museum of Modern Art.

Jackson Pollock, Art of This Century, March 19–April 14.

1946

Jackson Pollock, Art of This Century, April 2–20.

1947

Jackson Pollock, Art of This Century, January 14–February 1.

1948

Jackson Pollock: Recent Paintings, Betty Parsons Gallery, New York, January 5–23.

1949

Jackson Pollock: Recent Paintings, Betty Parsons Gallery, January 24–February 12.

Jackson Pollock: Paintings, Betty Parsons Gallery, November 21–December 10.

1950

Jackson Pollock, Museo Correr, Venice, July 21–August 21.

Jackson Pollock, Galleria d'Arte del Naviglio, Milan, October 21–November 30.

Jackson Pollock, Betty Parsons Gallery, November 28–December 16.

1951

Jackson Pollock, Betty Parsons Gallery, November 26–December 15.

1952

Jackson Pollock, Studio Paul Facchetti, Paris, March 7–31.

A Retrospective Show of the Paintings of Jackson Pollock, Bennington College, Bennington, Vermont, November 17–30, and tour to Lawrence Art Museum, Williams College, Williamstown, Massachusetts.

1954

Jackson Pollock: New Oils, Sidney Janis Gallery, New York, February 1–27.

1955

Fifteen Years of Jackson Pollock, Sidney Janis Gallery, November 28–December 31.

1956

Jackson Pollock, Museum of Modern Art, New York, December 19–February 3, 1957.

1957

Jackson Pollock Drawings, Sidney Janis Gallery, November 4–30.

1958

Jackson Pollock: 1912–1956, Museu de Arte Moderna, São Paulo, September 22–December 31, and Museum of Modern Art International Council tour to Galleria Nazionale d'Arte Moderna, Rome; Kunsthalle, Basel; Stedelijk Museum, Amsterdam; Kunstverein, Hamburg; Hochschule für Bildende Kunst, Berlin; Whitechapel Art Gallery, London; Musée National d'Art Moderne, Paris (*Jackson Pollock et la nouvelle peinture américaine*).

Jackson Pollock, Sidney Janis Gallery, November 3–29.

1961

Jackson Pollock: Paintings, Drawings, and Watercolors from the Collection of Lee Krasner Pollock, Marlborough Fine Art, London, June.

Jackson Pollock, Kunstverein für die Rheinlande und Westfalen, Düsseldorf, September 5–October 8.

Jackson Pollock, Kunsthaus, Zurich, October 24–November 29.

1962

Jackson Pollock, Marlborough Galleria d'Arte,

Rome, October–November, and tour to Toninelli Arte Moderna, Milan.

1963

Jackson Pollock, Moderna Museet, Stockholm, February–April.

1964

Jackson Pollock: Early Work, Griffin Gallery, New York, January 7–25.

Jackson Pollock, Marlborough-Gerson Gallery, New York, January 14–February 15.

1967

Jackson Pollock, Museum of Modern Art, April 5–June 4, and tour to Los Angeles County Museum of Art.

1968

Jackson Pollock: Works on Paper, Walker Art Center, Minneapolis, February 11–March 10, and tour to University of Maryland, College Park; Museum of Contemporary Art, Chicago; Seattle Art Museum; Baltimore Museum of Art; Montreal Museum of Fine Arts; Rose Art Museum, Brandeis University, Waltham, Massachusetts.

1969

Jackson Pollock: Black and White, Marlborough-Gerson Gallery, March 8–31.

1970

Jackson Pollock: Psychoanalytic Drawings, Whitney Museum of American Art, New York, October 10–November 15.

1977

Jackson Pollock: Works on Paper, Berry-Hill Galleries, New York, January 18–February 5.

1978

Jackson Pollock: New-Found Works, Yale University Art Gallery, New Haven, Connecticut, October 5–November 26, and tour to National Collection of Fine Arts, Smithsonian Institution, Washington, D.C.; David and Alfred Smart Gallery, University of Chicago.

1979

Jackson Pollock: Drawing into Painting, Museum of Modern Art, Oxford, April 1–May 13, and tour to Städtische Kunsthalle, Düsseldorf; Fundaçao Calouste Gulbenkian, Lisbon; Musée d'Art Moderne de la Ville de Paris, Paris; Stedelijk Museum, Amsterdam; Museum of Modern Art, New York.

1980

Jackson Pollock: The Black Pourings, 1951–1953, Institute of Contemporary Art, Boston, May 6–June 29.

Hans Namuth: Pollock Painting, 1950–1951, Castelli Graphics, New York, October 25–November 15.

1982

Jackson Pollock, Centre Georges Pompidou, Musée National d'Art Moderne, Paris, January 21–April 19, and tour to Städtische Galerie im Städelschen Kunstinstitut, Frankfurt.

Group Exhibitions

1935

Eighth Exhibition of Watercolors, Pastels, and Drawings by American and French Artists, Brooklyn Museum, February 1–28.

1937

Eighteenth Exhibition: New York Artists, Municipal Galleries, New York, February 3–21.

Federal Art, Federal Art Gallery, New York, October.

1942

American and French Paintings, McMillen Inc., New York, January 20–February 6.

Artists for Victory, Metropolitan Museum of Art, New York, December 7–February 22, 1943.

1943

Exhibition of Collage, Art of This Century, New York, April 15–May 15.

Spring Salon, Art of This Century, May 18–June 26.

Natural, Insane, Surrealist Art, Art of This Century, November 30–December 31.

1944

Abstract and Surrealist Art in the United States, Cincinnati Art Museum, February 8–March 12, and tour.

First Time in America, Art of This Century, April 11–May.

Group Exhibition, Pinacotheca Gallery, New York, May 9–27.

Abstract and Surrealist Art in America, Mortimer Brandt Gallery, New York, November 29–December 30.

1945

The Critic's Choice of Contemporary American Painting, Cincinnati Art Museum, March 10–April 8.

A Problem for Critics, 67 Gallery, New York, May 14–June 30.

Contemporary American Painting Exhibition, California Palace of the Legion of Honor, San Francisco, May 17–June 17.

1946

Annual Exhibition of Contemporary American Painting, Whitney Museum of American Art, New York, December 10–January 16, 1947 (also included in 1947–52).

1947

Large-Scale Modern Paintings, Museum of Modern Art, New York, April 1–May 4.

Fifty-eighth Annual Exhibition of American Paintings and Sculpture, Abstract and Surrealist American Art, Art Institute of Chicago, November 6–January 11, 1948 (also included in 1951, 1954).

1948

Twenty-fourth Venice Biennale: La Collezione Peggy Guggenheim, Venice, May 29–September 30 (also included in 1950, 1956).

Third Annual Exhibition of Contemporary Painting, California Palace of the Legion of Honor, November 30–January 16, 1949.

1949

La Collezione Guggenheim, La Strozzina, Strozzi Palace, Florence, February 19–March 10.

Contemporary American Painting, University of Illinois, Urbana, February 27–April 3 (also included in 1950, 1951, 1953).

Seventeen Artists, Guild Hall, East Hampton, New York, July 7–26.

Sculpture by Painters, Museum of Modern Art, New York, August 3–October 5, and Department of Circulating Exhibitions tour.

The Intrasubjectives, Samuel M. Kootz Gallery, New York, September 14–October 3.

1950

Amerika Schildert, Stedelijk Museum, Amsterdam, June 16–September 11.

Young Painters in U.S. and France, Sidney Janis Gallery, New York, October 23–November 11.

1951

Surrealisme & abstractie keuze uit de verzameling Peggy Guggenheim, Stedelijk Museum, January 19–February 26, and tour.

Abstract Painting and Sculpture in America, Museum of Modern Art, New York, January 23–March 25.

Sculpture by Painters, Peridot Gallery, New York, March 27–April 21.

Ninth Street Show, 60 East Ninth Street, New York, May 21–June 10.

1 Bienal de São Paolo, Museu de Arte Moderna, São Paulo, Brazil, October–December (also included in 1957).

Ben Shahn, Willem de Kooning, Jackson Pollock, Arts Club of Chicago, October 2–27.

1952

Fifteen Americans, Museum of Modern Art, New York, April 9–July 27.

International Exhibition of Contemporary Painting, Carnegie Institute, Pittsburgh, October 16–December 14.

1953

Abstract Expressionists, Baltimore Museum of Art, March 3–29.

Douze Peintres et sculpteurs américaines contemporaines, Musée National d'Art Moderne, Paris, April 24–June 8.

1954

Younger American Painters: A Selection, Solomon R. Guggenheim Museum, New York, May 12–July 25.

1955

Tendences actuelles, Kunsthalle, Bern, January 29–March 6.

Cinquante Ans d'art aux Etats-Unis, Musée National d'Art Moderne, March 31–May 15.

The New Decade, Whitney Museum of American Art, May 11–August 7, and tour.

1956

Abstract Art 1910 to Today, Newark Museum, April 27–June 10.

1958

Nature in Abstraction, Whitney Museum of American Art, January 14–March 16, and tour.

1959

Jackson Pollock et la nouvelle peinture américaine, Musée National d'Art Moderne, January 16–February 15.

The New American Painting, Museum of Modern Art, New York, May 28–September 8, and International Program tour.

Documenta 2, Museum Fridericianum, Kassel, West Germany, July 11–October 11 (also included in 1964).

New Images of Man, Museum of Modern Art, New York, September 30–November 29, and tour.

1960

60 American Painters 1960, Walker Art Center, Minneapolis, April 3–May 8.

1961

American Abstract Expressionists and Imagists, Solomon R. Guggenheim Museum, October 13–December 31.

1963

Idole und Dämonan, Museum des 20. Jahrhunderts, Vienna, July 5–September 1.

1964

Painting and Sculpture of a Decade 54–64, Tate Gallery, London, April 22–June 28.

Within the Easel Convention: Sources of Abstract-Expressionism, Harvard University, Fogg Art Museum, Cambridge, May 7–June 7.

Between the Fairs: 25 Years of American Art 1939–1964, Whitney Museum of American Art, June 24–September 23.

The Peggy Guggenheim Collection, Tate Gallery, December 31–March 7, 1965.

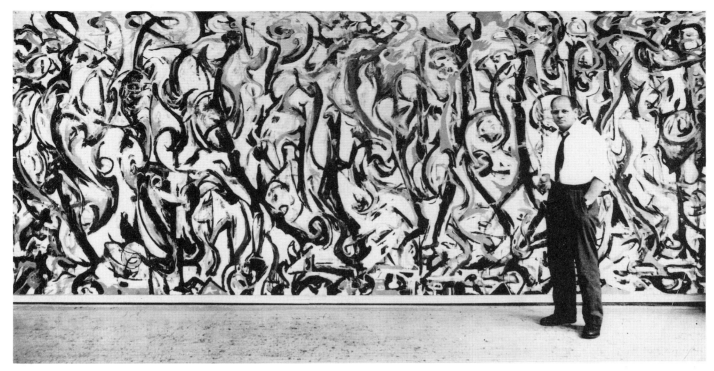

108. Jackson Pollock standing in front of *Mural*, 1947

1966

Federal Art Patronage 1933 to 1943, University of Maryland Art Gallery, College Park, April 6–May 13.

1967

Kompas 3, Stedelijk-Van Abbemuseum, Eindhoven, November 9–December 17.

1968

Dada, Surrealism, and Their Heritage, Museum of Modern Art, New York, March 27–June 9.

The 1930's: Painting and Sculpture in America, Whitney Museum of American Art, October 15–December 1.

1969

New York Painting and Sculpture 1940–1970, Metropolitan Museum of Art, October 18–February 1.

Painting in New York: 1944–1969, Pasadena Art Museum, Pasadena, California, November 24–January 11, 1970.

1970

Color and Field 1890–1970, Albright-Knox Art Gallery, Buffalo, New York, September 15–November 1, and tour.

1971

Von Picasso bis Warhol, Kunsthalle, Cologne, March 6–April 18.

1973

Futurism: A Modern Focus, Solomon R. Guggenheim Museum, November 16–February 3.

1974

Surrealität Bildrealität 1924–1974, Städtische Kunsthalle, Düsseldorf, December 8–February 2, 1975.

1976

Twentieth-Century American Drawing: Three Avant-Garde Generations, Solomon R. Guggenheim Museum, January 23–March 21.

The Natural Paradise: Painting in America 1800–1950, Museum of Modern Art, New York, October 1–November 30.

Acquisitions Priorities: Aspects of Postwar Painting in America, Solomon R. Guggenheim Museum, October 15–January 16.

1977

Surrealism and American Art 1931–1947, Rutgers University Art Gallery, New Brunswick, New Jersey, March 5–April 24.

America as Art, National Collection of Fine Arts, Smithsonian Institution, Washington, D.C., April 30–November 7.

Paris-New York, Musée National d'Art Moderne, June 1–September 19.

Perceptions of the Spirit in Twentieth-Century American Art, Indianapolis Museum of Art, September 20–November 27, and tour.

Kunst aus U.S.A. nach 1950: Amerikaner, Kunstsammlung Nordrhein-Westfalen, Düsseldorf, October 28–January 8, 1978.

1978

Dada and Surrealism Reviewed, Hayward Gallery, London, January 11–March 27, 1978.

Abstract Expressionism: The Formative Years, Cornell University, Herbert F. Johnson Museum of Art, Ithaca, New York, March 30–May 14, and tour.

The Subjects of the Artist: American Art at Mid-Century, National Gallery of Art, Washington, D.C., June 1–January 14, 1979.

1979

The Spirit of Surrealism, Cleveland Museum of Art, October 3–November 25.

1980

The Fifties: Aspects of Painting in New York, Hirshhorn Museum and Sculpture Garden, Smithsonian Institution, Washington, D.C., May 22–September 21.

17 Abstract Artists of East Hampton: The Pollock Years 1946–1956, Parrish Art Museum, Southampton, New York, July 20–September 14, and tour.

American Figure Painting: 1950–1980, Chrysler Museum, Norfolk, Virginia, October 17–November 30.

Amerika Traum und Depression 1920–1940, Akademie der Künste, Berlin, November 9–December 28, and tour.

1981

Paris-Paris: Créations en France 1937–1957, Musée National d'Art Moderne, May 28–November 2.

Westkunst, Museum der Stadt, Cologne, May 30–August 16.

Krasner/Pollock: A Working Relationship, Guild Hall Museum, East Hampton, August 8–October 4, and tour.

Public Collections

Amsterdam, The Netherlands, Stedelijk
 Museum
Andover, Massachusetts, Phillips Academy,
 Addison Gallery of American Art
Baltimore, Maryland, Baltimore Museum of Art
Bloomington, Indiana, Indiana University Art
 Museum
Bologna, Italy, Galleria Communale d'Arte
 Modérna
Boston, Massachusetts, Museum of Fine Arts
Buffalo, New York, Albright-Knox Art Gallery
Cambridge, Massachusetts, Harvard
 University, Fogg Art Museum
Chicago, Illinois, Art Institute of Chicago
Dallas, Texas, Dallas Museum of Fine Arts
Düsseldorf, West Germany, Kunstsammlung
 Nordrhein-Westfalen
East Hampton, Long Island, New York, Guild
 Hall

Edinburgh, Scotland, Scottish National Gallery
 of Modern Art
Hartford, Connecticut, Wadsworth Atheneum
Helena, Montana, Montana Historical Society
Houston, Texas, Museum of Fine Arts
Houston, Texas, Sarah Campbell Blaffer
 Foundation
Iowa City, Iowa, University of Iowa Museum
 of Art
Kansas City, Missouri, William Rockhill
 Nelson Gallery of Art and Mary Atkins
 Museum of Fine Arts
Kurashiki City, Okayama Prefecture, Japan,
 Ohara Museum
London, England, Tate Gallery
New Britain, Connecticut, New Britain
 Museum of American Art
New Haven, Connecticut, Yale University Art
 Gallery
New Orleans, Louisiana, New Orleans
 Museum of Art
New York City, New York, Metropolitan
 Museum of Art
New York City, New York, Museum of
 Modern Art
New York City, New York, Solomon R.
 Guggenheim Museum
New York City, New York, Whitney Museum
 of American Art
Norfolk, Virginia, Chrysler Museum
Oberlin, Ohio, Allen Memorial Art Museum,
 Oberlin College
Omaha, Nebraska, Joslyn Art Museum

Ottawa, Canada, National Gallery of Canada
Paris, France, Musée National d'Art Moderne
Pittsburgh, Pennsylvania, Museum of Art,
 Carnegie Institute
Providence, Rhode Island, Museum of Art,
 Rhode Island School of Design
Purchase, New York, State University of New
 York College at Purchase, Neuberger
 Museum
Rio de Janeiro, Museu de Arte Moderna do
 Rio de Janeiro
Rochester, New York, University of Rochester,
 Memorial Art Gallery
Rome, Galleria Nazionale d'Arte Moderna
Saint Louis, Missouri, Shoenberg Foundation
Saint Louis, Missouri, Washington University
 Gallery of Art
San Antonio, Texas, Marion Koogler McNay
 Art Institute
San Francisco, California, San Francisco
 Museum of Modern Art
Seattle, Washington, Seattle Art Museum
Seattle, Washington, Virginia Wright
 Foundation
Stockholm, Sweden, Moderna Museet
Stuttgart, West Germany, Staatsgalerie
 Stuttgart
Tehran, Iran, Tehran Museum of Contem-
 porary Art
Tel Aviv, Israel, Tel Aviv Museum
Tokyo, Japan, National Museum of Western
 Art
Tokyo, Japan, Seibu Museum of Art
Tucson, Arizona, University of Arizona
 Museum of Art
Utica, New York, Munson-Williams-Proctor
 Institute
Venice, Italy, Peggy Guggenheim Foundation
Washington, D.C., Hirshhorn Museum and
 Sculpture Garden, Smithsonian Institution
Washington, D.C., National Gallery of Art
Washington, D.C., National Museum of
 American Art, Smithsonian Institution
Washington, D.C., Phillips Collection
West Palm Beach, Florida, Norton Gallery and
 School of Art, Art Museum of the Palm
 Beaches

109. *Number 31, 1949*, 1949
Oil, enamel, and aluminum paint on gesso ground
on paper, mounted on composition board,
30¼ x 22 in.
Private collection

Selected Bibliography

Interviews, Statements, and Writings

Pollock, Jackson. Statement. In Janis, Sidney. *Abstract and Surrealistic Art in America.* New York: Reynal and Hitchcock, 1944, p. 112.

————. *Arts and Architecture* 61 (February 1944): 14. Responses to a questionnaire formulated by Howard Putzel and Jackson Pollock. Reprinted in Ellen H. Johnson, ed., *American Artists on Art from 1940 to 1980,* New York: Harper and Row, 1982, pp. 1–4.

————. "My Painting." *Possibilities* 1 (Winter 1947): 78–83. Reprinted in Ellen H. Johnson, ed., *American Artists on Art,* pp. 4–5.

————. "Unframed Space." *New Yorker* 26 (August 5, 1950): 16. Statements by Lee Krasner and Jackson Pollock.

————. Narration for the film *Jackson Pollock* by Hans Namuth and Paul Falkenberg, 1951. Typescript in the Museum of Modern Art Library.

————. Excerpt from a letter to Alfonso Ossorio and Edward Dragon, June 7, 1951. In *New York School: The First Generation,* exhibition catalog. Los Angeles: Los Angeles County Museum of Art, 1965, p. 25.

————. Statement. In Rodman, Selden. *Conversations with Artists.* New York: Devin-Adair, 1957, pp. 76–87. Interview held at Springs, Long Island, Summer 1956.

Wright, William. Interview in 1950 taped at Springs, Long Island, and broadcast on radio station WERI in Westerly, Rhode Island. Published in "The Artists Speak: Part Six." *Art in America* 53 (August–September 1965): 110–30. Reprinted in Ellen H. Johnson, ed., *American Artists on Art,* pp. 5–10.

Monographs and Solo-Exhibition Catalogs

Alloway, Lawrence. *Jackson Pollock: Paintings, Drawings, and Watercolors from the Collection of Lee Krasner Pollock,* exhibition catalog. London: Marlborough Fine Art, 1961. A German translation was published in 1961 for the Kunstverein für de Rheinlände und Westfalen, Düsseldorf, with a preface by Karl-Heinz Hering, and for the Kunsthaus Zurich, with a preface by Eduard Hüttinger. An Italian translation of the introduction was published in 1962 in the catalogs for the exhibitions in Rome and Milan.

————. *Jackson Pollock,* exhibition catalog. Rome: Marlborough Galleria d'Arte, 1962. A nearly identical catalog was published for the exhibition at Toninelli Arte Moderna, Milan.

Bozo, Dominique, et al. *Jackson Pollock,* exhibition catalog. Paris: Centre Georges Pompidou, Musée National d'Art Moderne, 1982. Includes a documentary chronology. A short version of the catalog was published for the exhibition at the Städtische Galerie im Städelschen Kunstinstitut, Frankfurt, with an introduction by Klaus Gallwitz.

Busignani, Alberto. *Jackson Pollock.* Florence: Sansoni Editore, 1970.

Crispolti, Enrico. *Pollock: Un Saggio critico.* Milan: Pesce d'Oro, 1958.

Davis, W. N. M. Preface to *Jackson Pollock,* exhibition catalog. New York: Art of This Century, 1947.

Fifteen Years of Jackson Pollock, exhibition catalog. New York: Sidney Janis Gallery, 1955.

Friedman, B. H. *Jackson Pollock: Energy Made Visible.* New York: McGraw-Hill Book Company, 1972.

Gagnon, François-Marc; Dubreuil-Blondin, Nicole; Payant, René; Lamarche, Lise. *Jackson Pollock: Questions.* Montreal: Musée d'Art Contemporain, 1979. Preface by Louise Letocha.

Guggenheim, Peggy. Introduction to *Jackson Pollock,* exhibition catalog. Venice: Museo Correr, 1950. One version of this catalog also contains text by Bruno Alfieri.

Hultén, K. G. *Jackson Pollock,* exhibition catalog. Stockholm: Moderna Museet, 1963.

Hunter, Sam. *Jackson Pollock,* exhibition catalog. New York: Museum of Modern Art, 1956. *The Museum of Modern Art Bulletin* 24, no. 2 (1956–57). Translated into various languages for catalogs for the International Council exhibitions, 1957–59.

Jackson Pollock, exhibition catalog. New York: Sidney Janis Gallery, 1958.

Kambartel, Walter. *Jackson Pollock 'Number 32, 1950.'* Stuttgart: Philip Reclam, 1970.

Lieberman, William S., introduction, and Friedman, B. H., interview with Lee Krasner Pollock. *Jackson Pollock: Black and White,* exhibition catalog. New York: Marlborough-Gerson Gallery, 1969.

————. *Jackson Pollock: The Last Sketchbook.* New York: Johnson Reprint and Harcourt, Brace, Jovanovich, 1982. Limited edition of 525 copies.

Namuth, Hans, photographs; Krauss, Rosalind, and O'Connor, Francis V., text. *L'Atelier de Jackson Pollock.* Paris: Macula/Pierre Brochet, 1978. Translated, enlarged, and edited by Barbara Rose as *Pollock Painting,* New York: Agrinde Publications, 1980. Includes interview with Lee Krasner by Barbara Rose, reprints of 1969 interview with Lee Krasner by B. H. Friedman, "My Painting," and interview by William Wright.

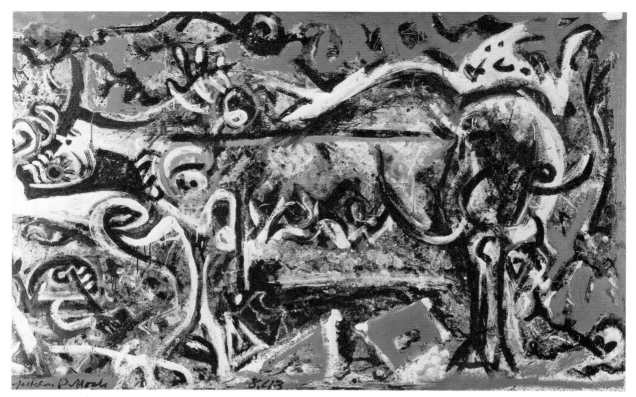

110. *The She-Wolf*, 1943
Oil, gouache, and plaster on canvas, 41⅞ x 67 in.
The Museum of Modern Art, New York
Purchase

O'Connor, Francis V. "The Genesis of Jackson Pollock: 1912 to 1943." Ph.D. dissertation, Baltimore: Johns Hopkins University, 1965.

————. *Jackson Pollock*, exhibition catalog. New York: Museum of Modern Art, 1967. Includes chronology with statements and reprints of exhibition reviews.

————, and Thaw, Eugene Victor, eds. *Jackson Pollock: A Catalogue Raisonné of Paintings, Drawings, and Other Works.* New Haven: Yale University Press, 1978. Includes a documentary chronology.

————, and Thaw, Eugene Victor. *Jackson Pollock: New-Found Works*, exhibition catalog. New Haven: Yale University Art Gallery, 1978.

————. *Jackson Pollock: The Black Pourings, 1951–1953*, exhibition catalog. Boston: Institute of Contemporary Art, 1980. Foreword by Stephen S. Prokopoff. Includes reprints of statements.

O'Hara, Frank. *Jackson Pollock*. New York: George Braziller, 1959. Includes reprints of statements.

Ossorio, Alfonso. *Jackson Pollock*, exhibition catalog. New York: Betty Parsons Gallery, 1951. Translated and reprinted in the catalog for the exhibition at Studio Paul Facchetti, Paris, 1952.

Putz, Ekkehard. *Jackson Pollock: Theorie und Bild.* Hildesheim and New York: G. Olms, 1975.

Originally the author's doctoral dissertation, Ruhr: Universität Bochum, 1973.

Robertson, Bryan. *Jackson Pollock*. New York: Harry N. Abrams, 1960. Other editions published in London by Thames and Hudson and in Cologne by DuMont Schauberg, 1961. Includes reprints of statements.

————. *Jackson Pollock*, exhibition catalog. New York: Marlborough-Gerson Gallery, 1964.

Rose, Bernice. *Jackson Pollock: Works on Paper.* New York: Museum of Modern Art and the Drawing Society, 1969.

————. *Jackson Pollock: Drawing into Painting*, exhibition catalog. New York: Museum of Modern Art, 1980. Translated and reprinted in various catalogs for the exhibition tour organized by the International Council, 1979–80.

Sweeney, James Johnson. *Jackson Pollock*, exhibition catalog. New York: Art of This Century, 1943. Reprinted in the catalog for the exhibition at the Arts Club of Chicago, 1945, and in *It Is* 4 (Autumn 1959): 56.

Tapié, Michel, and Ossorio, Alfonso. *Jackson Pollock*, exhibition catalog. Paris: Studio Paul Facchetti, 1952.

Tomassoni, Italo. *Pollock*. Florence: Sansoni Editore, 1968. Other editions translated and published in London by Thames and Hudson, 1969; in Paris by Flammarion, 1969; and in

New York by Grosset and Dunlap, 1978.

Wysuph, C. L. *Jackson Pollock: Psychoanalytic Drawings.* New York: Horizon Press, 1970.

Periodicals, Books, and Group-Exhibition Catalogs

Alloway, Lawrence. "Notes on Pollock." *Art International* 5 (May 1961): 38, 41, 90.

————. "Pollock's Black Paintings: The Recent Exhibition at Marlborough–Gerson." *Arts Magazine* 43 (May 1969): 40–43. Reprinted in *Topics in American Art since 1945.* New York: W. W. Norton, 1975.

Ashton, Dore. "Pollock: Le nouvel espace." *XXe Siècle* 17 (December 1961): 75-80.

————. "Jackson Pollock's Arabesque." *Arts Magazine* 53 (March 1979): 142–43. Entire issue devoted to Jackson Pollock.

"Beyond the Pasteboard Mask." *Time* 83 (January 17, 1964): 66–69. On the occasion of an exhibition at Marlborough Gallery.

Bloch, Susi. "Review: Jackson Pollock: A Catalogue Raisonné of Paintings, Drawings, and Other Works, 1978." *Art Journal* 39 (Fall 1979): 55–56.

Brach, Paul. "Tandem Paint: Krasner/Pollock."

Art in America 70 (March 1982): 92–95. Review of an exhibition at Guild Hall Museum.

Canaday, John. "Art: Pollock's Searching for a Symbol." *New York Times*, January 14, 1964, p. 29. Review of an exhibition at Marlborough-Gerson Gallery.

Carmean, E. A. "Jackson Pollock: Classic Paintings of 1950." In *American Art at Mid-Century: The Subjects of the Artist*, exhibition catalog. Washington, D.C.: National Gallery of Art, 1978, pp. 127–53.

————. "The Pollock Puzzle." *Washington Post*, March 21, 1982, sec. 1, pp. 1, 4.

————. "The Church Project: Pollock's Passion Themes." *Art in America* (Summer 1982): 110–22. Abridged, translated version of the second part of his essay in the Centre Georges Pompidou exhibition catalog.

Carter, Betsy. "Jackson Pollock's Drawings under Analysis." *Artnews* 76 (February 1977): 58–60. A discussion of the controversy over whether Pollock's psychoanalyst acted ethically in publicizing the drawings Pollock made while in analysis.

"Chaos, Damn It." *Time* 56 (November 20, 1950): 70–71. Response by Pollock in "Letters to the Editor" (December 11, 1950): 10.

Fitzsimmons, James. "Jackson Pollock." *Art Digest* 26 (December 15, 1951): 19. Review of an exhibition at Betty Parsons Gallery.

Frankenstein, Alfred. "Laying the Pollock Case to Rest." *Artnews* 76 (October 1977): 94–95. The accusation of Dr. Henderson, Pollock's psychiatrist, is dismissed.

Freke, David. "Jackson Pollock: A Symbolic Self-Portrait." *Studio International* 184 (December 1972): 217–21. A discussion of the autobiographical nature of his mythological paintings.

Fried, Michael. "Jackson Pollock." *Artforum* 4 (September 1965): 14–17.

Friedman, B. H. "Profile: Jackson Pollock." *Art in America* 43 (December 1955): 49, 58–59.

————. "A Reasoned Catalogue Is Almost a Life." *Arts Magazine* 53 (March 1979): 100–102. Entire issue devoted to Jackson Pollock.

Friedman, Stanley P. "Loopholes in 'Blue Poles.'" *New York* 6 (October 29, 1973): 48–51.

Glaser, Bruce. "Jackson Pollock: An Interview with Lee Krasner." *Arts Magazine* 41 (April 1967): 36–39.

Glueck, Grace. "Scenes from a Marriage: Krasner and Pollock." *Artnews* 80 (December 1981): 57–61. Includes statements by Lee Krasner.

Goodnough, Robert. "Pollock Paints a Picture." *Artnews* 50 (May 1951): 38–41, 60–61. Condensed in *Artnews* 76 (November 1977): 162–64.

Gordon, Donald E. "Department of Jungian Amplification, One: Pollock's 'Bird,' or How Jung Did Not Offer Much Help in Myth-Making." *Art in America* 68 (October 1980): 43–53. A response to William Rubin's article on Pollock's Jungian critics.

Greenberg, Clement. "The Jackson Pollock Market Soars." *New York Times Magazine*, April 16, 1961, pp. 42, 132–35. "Letters to the Editor." April 30, 1961.

————. "Jackson Pollock: 'Inspiration, Vision, Intuitive Decision.'" *Vogue* 149 (April 1, 1967): 160–61.

Hess, Thomas B. "Jackson Pollock 1912–1956." *Artnews* 55 (September 1956): 44–45, 57.

————. "Pollock: The Art of a Myth." *Artnews* 62 (January 1964): 39–41, 62–65. On the occasion of exhibitions at Marlborough-Gerson Gallery and Griffin Gallery.

————. "Editorial: Artists' Symposium on Jackson Pollock." *Artnews* 66 (April 1967): 27. William Rubin's reply, with rejoinder, in "Editor's Letters" (May 1967): 6.

Hunter, Sam. "Jackson Pollock Catalogue Raisonné: A Vast Impressive Panoply." *Artnews* 77 (November 1978): 24, 27.

"Jackson Pollock: An Artists' Symposium, Part One." *Artnews* 66 (April 1967): 28–33, 59–67. "Part Two." (May 1967): 27–29, 69–71. Discussion in the Summer issue, p. 6.

"Jackson Pollock. Is He the Greatest Living Painter in the United States?" *Life* 27 (August 8, 1949): 42–44.

Johnson, Ellen H. "Jackson Pollock and Nature." *Studio* 185 (June 1973): 257–62.

Judd, Donald. "Jackson Pollock." *Arts Magazine* 41 (April 1967): 32–35.

Kagan, Andrew. "Improvisations: Notes on Jackson Pollock and the Black Contribution to American High Culture." *Arts Magazine* 53 (March 1979): 96–99.

Kaprow, Allan. "The Legacy of Jackson." *Artnews* 57 (October 1958): 24–26, 55–57. Excerpt reprinted in Ellen H. Johnson, ed., *American Artists on Art*, pp. 57–58. Reply by Irving H. Sandler in "Editor's Letters" (December 1958): 6. Rejoinder by Kaprow (February 1959): 6.

————. "Impurity." *Artnews* 61 (January 1963): 30–55. See pp. 53–54. An examination of four works, including Pollock's *Number 32, 1950*.

Karp, Ivan C. "In Memoriam: The Ecstasy and Tragedy of Jackson Pollock, Artist." *Village Voice*, September 26, 1956.

Kramer, Hilton. "Jackson Pollock and Nicolas de Staël: Two Painters and Their Myths." *Arts Yearbook* 3 (1959): 52–60. See pp. 53–57.

————. "The Inflation of Jackson Pollock." *New York Times*, April 9, 1967, sec. D, p. 25. Review of an exhibition at the Museum of Modern Art.

————. "Jackson Pollock: Energy Made Visible." *New York Times Magazine*, October 8, 1972, pp. 7–8, 34.

————. "The Jackson Pollock Myth." In *The Age of the Avant-Garde*. New York: Farrar, Straus and Giroux, 1973, pp. 335–41.

————. "Art: Jackson Pollock and Barnett Newman." *New York Times*, February 15, 1980, sec. C, p. 19. Reviews of exhibitions at the Museum of Modern Art and the Metropolitan Museum of Art.

Krauss, Rosalind. "Jackson Pollock's Drawings." *Artforum* 9 (January 1971): 58–61.

————. "Contra Carmean: The Abstract Pollock." *Art in America* 70 (Summer 1982): 123–31, 155.

Kroll, Jack. "A Magic Life." *Newsweek* 69 (April 17, 1967): 96–98.

Kuspit, Donald B. "To Interpret or Not To Interpret Jackson Pollock." *Arts Magazine* 53 (March 1979): 125–27. Entire issue devoted to Jackson Pollock.

Langhorne, Elizabeth L. "Jackson Pollock's 'The Moon Woman Cuts the Circle.'" *Arts Magazine* 53 (March 1979): 128–37. Entire issue devoted to Jackson Pollock.

Levine, Edward. "Mythical Overtones in the Work of Jackson Pollock." *Art Journal* 26 (Summer 1967): 366–68, 374.

Lowengrund, Margaret. "Pollock Hieroglyphics." *Art Digest* 23 (February 1, 1949): 19–20.

Mandeles, C. "Jackson Pollock and Jazz: Structural Parallels." *Arts Magazine* 56 (October 1981): 139–41.

O'Connor, Francis V. "The Genesis of Jackson Pollock: 1912 to 1943." *Artforum* 5 (May 1967): 16–23. Based on research for his Ph.D. dissertation.

————. "Hans Namuth's Photographs of Jackson Pollock as Art Historical Documentation." *Art Journal* 39 (Fall 1979): 48–49.

O'Doherty, Brian. "Jackson Pollock's Myth."

In *American Masters: The Voice and the Myth*. New York: Random House, 1973, pp. 80–111.

O'Hara, Frank. "Jackson Pollock." In *Art Chronicles 1954–1966*. New York: George Braziller, 1975, pp. 12–39.

Pierre, José. "Surrealism, Jackson Pollock and Lyric-Abstraction." In *Surrealist Intrusion in the Enchanters' Domain*, exhibition catalog. New York: D'Arcy Galleries, 1960, pp. 30–35.

Plessix, Francine du and Gray, Cleve. "Who Was Jackson Pollock?" *Art in America* 55 (May–June 1967): 48–59. Interviews with Alfonso Ossorio, Betty Parsons, Lee Krasner, Tony Smith.

Polcari, Stephen. "Jackson Pollock and Thomas Hart Benton." *Arts Magazine* 53 (March 1979): 120–24. Entire issue devoted to Jackson Pollock.

Raynor, Vivien. "Jackson Pollock in Retrospect —'He Broke the Ice.'" *New York Times Magazine*, April 2, 1967, pp. 50–76.

Rose, Barbara. "Hans Namuth's Photographs and the Jackson Pollock Myth: Part One: Media Impact and the Failure of Criticism." *Arts Magazine* 53 (March 1979): 112–16. Entire issue devoted to Jackson Pollock. "Part Two: 'Number 29, 1950'": 117–19. Greenberg, Clement. "Letter to the Editor," and reply by Barbara Rose, *Arts Magazine* 53 (April 1979): 24.

Rosenberg, Harold. "The Mythic Act." *New Yorker* 43 (May 6, 1967): 162–71.

Roskill, Mark. "Jackson Pollock, Thomas Hart Benton, and Cubism: A Note." *Arts Magazine* 53 (March 1979): 144. Entire issue devoted to Jackson Pollock.

Rubin, David S. "A Case for Content: Jackson Pollock's Subject Was the Automatic Gesture." *Arts Magazine* 53 (March 1979): 103–9. Entire issue devoted to Jackson Pollock.

Rubin, William. "Notes on Masson and Pollock." *Arts Magazine* 34 (November 1959): 36–43. Correction made in December issue, p. 9.

————. "Jackson Pollock and the Modern Tradition: Part One." *Artforum* 5 (February 1967): 14–22. "Part Two" (March 1967): 28–37. "Part Three" (April 1967): 18–31. "Part Four" (May 1967): 28–33. Harold Rosenberg, in "Letters" (April 1967): 6–7. Reply by Rubin (May 1967): 4.

————. "Pollock as Jungian Illustrator: The Limits of Psychological Criticism." *Art in America* 67 (November 1979): 104–23. (December 1979): 72–91.

Sandler, Irving. "The Influence of Impressionism on Jackson Pollock and His Contemporaries." *Arts Magazine* 53 (March 1979): 110–11. Entire issue devoted to Jackson Pollock.

————; Rubin, D. S.; Langhorne, E.; Rubin, William. "Department of Jungian Amplification, Part Two: More on Rubin on Pollock." *Art in America* 68 (October 1980): 57–67.

Steinberg, Leo. "Month in Review." *Arts Magazine* 30 (December 1955): 43–44, 46. Review of an exhibition at Sidney Janis Gallery.

Stevens, Mark. "Quests in Paint." *Newsweek* 92 (October 23, 1978): 138–39. Reviews of an exhibition at Yale University Art Gallery and a book by Francis V. O'Connor.

Stuckey, Charles F. "Another Side of Jackson Pollock." *Art in America* 65 (November 1977): 80–91.

Tillim, Sidney. "Jackson Pollock: A Critical Evaluation." *College Art Journal* 16 (Spring 1957): 242–43.

Tyler, Parker. "Jackson Pollock: The Infinite Labyrinth." *Magazine of Art* 43 (March 1950): 92–93.

————. "Hopper/Pollock: The Loneliness of the Crowd and the Loneliness of the Universe: An Antiphonal." *Artnews Annual* 26 (1957): 86–107.

Valliere, James T. "The El Greco Influence on Jackson Pollock's Early Works." *Art Journal* 24 (Fall 1964): 6–9.

————. "De Kooning on Pollock." *Partisan Review* 34 (Fall 1967): 603–5. Interview.

Welch, Jonathan. "Jackson Pollock's 'The White Angel' and the Origins of Alchemy." *Arts Magazine* 53 (March 1979): 138–41. Entire issue devoted to Jackson Pollock.

Wolf, Ben. "Non-Objectives by Pollock." *Art Digest* 21 (January 15, 1947): 21. Review of an exhibition at Art of This Century.

Wolfe, Judith. "Jungian Aspects of Jackson Pollock's Imagery." *Artforum* 11 (November 1972): 65–73.

Wysuph, C. L. "Behind the Veil." *Artnews* 69 (October 1970): 52–55, 80. Drawings made as an aid to psychoanalysis, shown at the Whitney Museum of American Art.

Films

Jackson Pollock. Produced by Hans Namuth and Paul Falkenberg. Narration by Jackson Pollock. 1951. 16mm.

111. (*Black and White Polyptych*), c. 1950
Oil on canvas, 24 x 80 in.
Private collection

Index

The photographers and the sources of photographic material other than those indicated in the captions are as follows: Lee Brian, Palm Beach, Florida: plate 96; Will Brown, Philadelphia: plate 88; Courtesy Christie's, New York: plate 6; Geoffrey Clements, New York: plates 27, 43, 48, 57, 73, 78, 87, 95; Bruce C. Jones, New York: plate 26; Courtesy Robert Miller Gallery, New York: plate 19; Hans Namuth: plates 8, 9, 40; Courtesy Lee Krasner Pollock: plates 5, 54, 106–8; O. E. Nelson, New York: plates 4, 7, 12, 15, 16, 21; Glenn Steigelman, New York: plates 33, 60; Courtesy E. V. Thaw & Co., New York: plate 79.

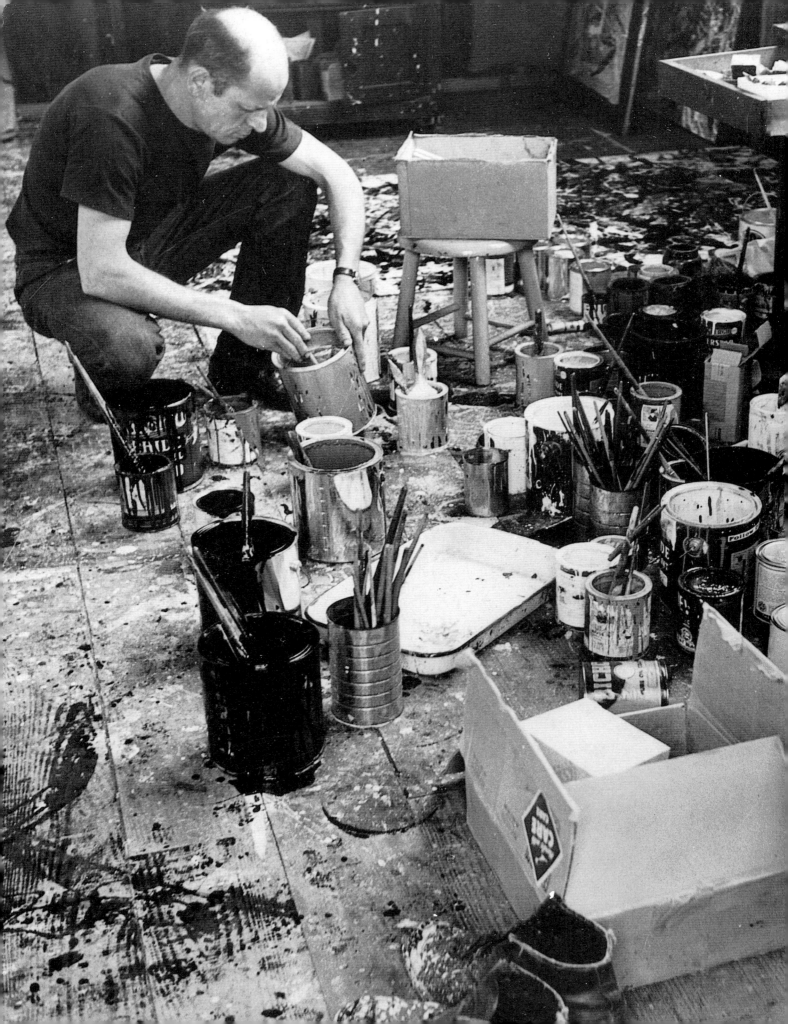